MEXICAN AMERICAN BASEBALL IN THE INLAND EMPIRE

Dear Lillian and Helen Hernandez,

I hope you enjoy the book. Can't wait to hear more about Kiko!

Saludos,
Mark Ocegueda

They Played This Game, Baseball

They played on Sundays, all day, all year,
In parks and sandlots, on grass or dirt,
Any neighborhood of baseball was home.

They played for their *familias* and *barrios*,
Fathers and sons, boys and girls, all played.

They played in a world just a little further east,
Not to prove they were better than, only this,
They were as good as, no more, no less.

They became more American playing baseball,
And the game, more Mexican American because
They played their way; with love, *con corazon*.

—Tomas Benitez

FRONT COVER: Tommie Encinas, of Pomona, is shown here winding up while playing with the Waco Pirates in 1948. Tommie's high leg kick was similar to Hall of Fame pitcher Juan Marichal's signature windup. (Courtesy of the Tommie Encinas family.)

COVER BACKGROUND: The 1939 Corona Athletics featured players like Ray Delgadillo and Natividad "Tito" Cortez. Delgadillo and Cortez displayed outstanding talent and were pioneer Mexican American baseball players in the Inland Empire. (Courtesy of Richard Cortez.)

BACK COVER: The San Bernardino Raiderettes pose for a team portrait during the 1950s. The Raiderettes, who played at Our Lady of Guadalupe's parking lot on Fifth Street and Pico Avenue, competed against various teams from various Inland Empire barrios, including Casa Blanca in Riverside and Cucamonga. (Courtesy of Armida Neri-Miller.)

MEXICAN AMERICAN BASEBALL IN THE INLAND EMPIRE

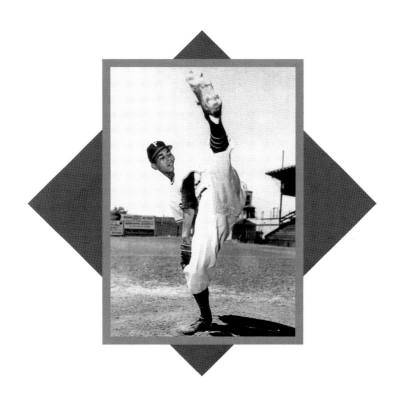

Richard A. Santillan, Mark A. Ocegueda, and Terry A. Cannon
Foreword by José M. Alamillo

Copyright © 2012 by Richard A. Santillan, Mark A. Ocegueda, and Terry A. Cannon
ISBN 978-0-7385-9316-6

Published by Arcadia Publishing
Charleston, South Carolina

Printed in the United States of America

Library of Congress Control Number: 2011939876

For all general information, please contact Arcadia Publishing:
Telephone 843-853-2070
Fax 843-853-0044
E-mail sales@arcadiapublishing.com
For customer service and orders:
Toll-Free 1-888-313-2665

Visit us on the Internet at www.arcadiapublishing.com

For Teresa, the wind beneath my wings

—*Richard*

Para mi mamá y mi papá, María Castro y Daniel Ocegueda, gracias por todo

—*Mark*

For Mary, for her support and inspiration and for tolerating—and mostly enjoying—a lifetime's worth of baseball chatter

—*Terry*

CONTENTS

Foreword		6
Acknowledgments		7
Introduction		8
1.	Mexican American Baseball: The Golden State	9
2.	Mexican American Baseball: The San Bernardino Valley	27
3.	Mexican American Baseball: Corona, Riverside, and the Coachella Valley	51
4.	Mexican American Baseball: The Pomona Valley	69
5.	Transnational and Military Baseball: Mexican Americans Playing Abroad	85
6.	Professional Baseball: American Dreams for Mexican Americans	103
7.	The Latino Baseball History Project: El Campo de Sueños	119
Bibliography		126
Latino Baseball History Project Advisory Board		127

FOREWORD

This impressive collection of photographs highlights the multiple ways in which Mexican Americans have redefined the meaning of baseball. For some, baseball was one of the few recreational activities they could afford with their low wages from agricultural, railroad, factory, and packinghouse jobs in the Inland Empire. They spent much of their weekends recuperating by playing and watching baseball with family and friends. The team names, jerseys, nicknames, and championship titles conveyed a sense of pride from which they could gain strength and confidence that would extend to other arenas in life. On the surface, it seems baseball was merely a recreational pastime, but for some, it became a vehicle towards empowering themselves and their communities. Mexican American baseball teams generated a positive image of their community under siege from repatriation campaigns, racial segregation, and negative press coverage during the 1930s and 1940s. For the baseball players, becoming part of a team meant learning teamwork, self-discipline, and leadership skills that could be transferred into education, civil rights, and electoral politics.

Mexican American Baseball in the Inland Empire makes two important contributions to the fields of Latino/a studies and sports studies. First, it corrects the false notion that baseball was an exclusive, all-male sport. Photographs of Mexican American female baseball and softball players reveal their love for a game that challenged traditional gender roles and created new notions of femininity. Second, it emphasizes that national borders did not bound baseball. When opportunities to play were limited in the United States, Mexican Americans traveled south of the border to play or coach in Mexico's baseball leagues. Thus, baseball allowed Mexican Americans to reconnect with their Mexican identity while participating in a transnational circuit of teams, coaches, and promoters. These photographs of Mexican American baseball, deeply rooted in the memories of former players and their families of the Inland Empire, will now gain the visibility they deserve and will never be forgotten.

—José M. Alamillo

ACKNOWLEDGMENTS

The publication of *Mexican American Baseball in the Inland Empire* is mainly due to the commitment and enthusiasm of those associated with the Latino Baseball History Project at California State University, San Bernardino (CSUSB). Individuals involved with the project who supported the writing of this book include the staff at CSUSB's John M. Pfau Library, including Iwona Contreras, César and Sue Caballero, Ericka Saucedo, Jill Vassilakos-Long, Amina Romero, AnneMarie Hopkins, Stacy Magedanz, Juvette McNew, James Knight III, Carrie Lowe, Catrina Mancha, Mackenzie Von Kleist, Karina Echave, Renee Barrera, and Brandy Montoya. Special thanks to Manuel Veron, who served as research assistant to the book. Assistant professor of history Cherstin M. Lyon and students in her spring 2011 public and oral history course at CSUSB also made important contributions to the book.

The authors are indebted to the many players and their families who provided the vintage photographs and remarkable stories on the ensuing pages. We especially thank Danny Carrasco, who was a key liaison with players and families in the Inland Empire. Other players, community members, and organizations that deserve our full gratitude are Jim "Chayo" Rodriguez, Alex Rubalcava, Chris Laguna, Ron Cabrera, Manuel Martínez, Ernie Paramo, Bobby Carrasco, Pete Carrasco, Tony Martínez, Steve Martínez, David Martínez, Vince Padilla, Candy Solano, Felix Holguin, Richard Cortez, Carlos Uribe, Al Vásquez, the Tommie Encinas family, Angie Torrez Pippins, Chuck Briones, Pete Barrios Jr., Ernie Benzor, Charlie Sierra, Armando Pérez, Victor Reyes, Ray Pérez, Carmen Lujan, Bill Miranda, Nemorio "Willie" Alvarez-Tostado, Gil and Alma Gámez, Eddie Navarro, Marcelino Saucedo, Carmen Dominguez-Nevarez, Armida Neri-Miller, Sal Valdivia Jr., and the Guadalupe Cultural Arts and Education Center. We also remember the incredible life of Ray Martínez, who passed away in 2011. Any photographs not credited are courtesy of the Latino Baseball History Project.

Others who have lent generous support to the book and/or the Latino Baseball History Project include Dr. Francisco Balderrama; Dr. Vicki Ruiz; Roberta Martínez, Latino Heritage, Pasadena; Jerry Soifer, writer for the *Press-Enterprise*, Riverside; Pat Lambert, Pomona Public Library; Joan Cappocchi, Burbank Public Library; Olufunke Oluyemi, Cal Poly Pomona Library; Noella Benvenuti, Corona Heritage Park Museum; Frank Gonzales and Albert Gómez, County of Los Angeles Department of Parks and Recreation; Gloria Molina, Los Angeles County supervisor, first district; Carmelita Provision Company; Gilbert and Lucille Pérez; Abel Becerra; Aldo Ortiz; and Alex Montoya, Hispanic outreach coordinator for the San Diego Padres. Finally, we thank Arcadia Publishing and our editor, Amy Perryman.

INTRODUCTION

At the turn of the 20th century, the inland region of Southern California, more commonly known as the Inland Empire, sustained a thriving agricultural citrus industry that provided the economic pull factors for Mexican immigration into the San Bernardino Valley, the Pomona Valley, Riverside, Corona, and the Coachella Valley. Mexican immigrants labored within the citrus economy as pickers, packers, and other low-wage positions. In addition, various Santa Fe and Southern Pacific Railroad depots throughout the Inland Empire provided Mexican immigrants with additional employment. With the large influx of Mexican immigration during the first decades of the 20th century, long-lasting Mexican communities developed in the Inland Empire. As Mexican migrants settled in Inland Empire barrios, Mexican immigrants and their Mexican American progeny formed baseball teams that facilitated senses of community pride and ethnic identity for women and men. Many of the barrio baseball games were played on weekend afternoons in front of lively, overflowing crowds. Some fans even preferred to park their cars in the outfield and blare their horns after every home run. Both women and men formed community teams that allowed Mexican Americans to proclaim their social equality through athletic competition and to publicly demonstrate community strength.

This photo-documentary reveals baseball's social and cultural impact on the various Mexican communities within the Inland Empire. Particular emphasis is given to the era of segregation when Mexican immigrants and their Mexican American children experienced exclusion from various societal arenas, including schools, labor, theaters, politics, public recreational facilities, and sports. Comparable to the Negro Leagues of the Southern and Eastern United States, Mexican American baseball leagues developed in the context of segregation and discrimination during the interwar period. While some attention is given to the rise of individual professional and major-league players, the emphasis rests on the celebration of ethnic identity and community solidarity that Mexican American baseball leagues provided Inland Empire barrios. Although former players and members of the Mexican communities within the Inland Empire have not forgotten baseball's cultural and social significance, this book serves as one of the first efforts to present the history of Mexican American baseball in the Inland Empire's barrios.

Mexican American Baseball

The Golden State

Mexican American baseball in California dates back to at least the 1890s and was well established in nearly every Mexican American community by the early 1920s. On any given Sunday, baseball and softball teams competed on city parks and makeshift fields. Each game attracted many fans, especially family members and friends of the players.

There were commonalities associated with these games. Most of the players and fans attended church in the morning before heading out to the baseball diamond. The players, who practiced hard during the week after working at their jobs 10 to 12 hours a day, had to get the fields into shape before each game. Mexican food and beer were sold, and Mexican music and the Spanish language were heard. Spectators sat on the grass or on makeshift stands, and a baseball cap was passed around to collect gas money for the visiting team. After the game, the home team often went to the local bar to drink beer.

Unfortunately, these same communities shared other similarities. Mexican Americans confronted racial prejudice and discrimination in housing, health care, education, employment, and recreation. It was not uncommon for Mexican Americans throughout California to be forced to sit in certain sections of movie theatres, to swim in public pools only one day out of the week, to be barred from or assigned special times for use of public parks, to attend segregated schools with inferior classrooms, to work in the lowest paying and most dangerous jobs, to be denied meals in public restaurants, to live in the most rundown sections of town, and to be forced from their homes because of urban renewal programs.

Yet, despite these economic hardships and social forms of segregation, the greater Mexican American community in California endured and eventually overcame many of these institutional obstacles by organizing political and social organizations, labor movements, and religious groups, by filing lawsuits, and by establishing recreational clubs and facilities. The Mexican American community formed its own network of sports, including boxing, basketball, baseball, and softball. To Mexican Americans, sports were not just games—they were important elements of community identity, cultural affirmation, civil rights, and political empowerment.

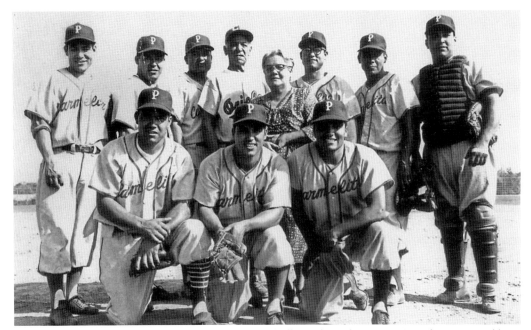

The Peña family was one of the most famous baseball families of East Los Angeles. Featured here are the nine brothers playing in an exhibition game for the Carmelita Provision Company at Belvedere Park in the late 1950s. Their father, William (second row, fourth from left), managed the team. Their mother, Victoria (second row), took loving care of the family while supporting her sons' and husband's baseball activities. (Courtesy of Richard Peña.)

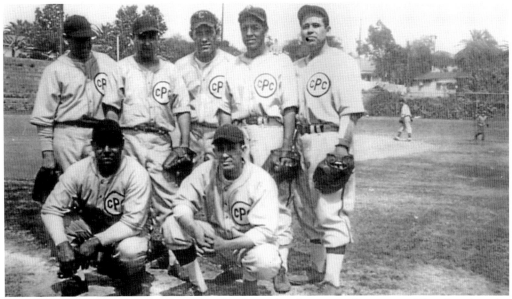

From the late 1940s through the 1970s, the Carmelita Provision Company of East Los Angeles won numerous championships. Since the company produced pork products, the team was known as the Chorizeros, or "sausage makers." Among the outstanding players on the 1947 team were Ray Armenta (second row, far right) and Gil Gámez Sr. (first row, far left). The little boy in the background is 10-year-old Tom Pérez Jr. (Courtesy of Tom Pérez Jr.)

Wally Poon had an illustrious baseball career in the 1940s and 1950s as one of the few non–Mexican Americans to play in East Los Angeles. A Chinese American, Poon grew up with Mexicans, attended East Los Angeles College, and served the community in a variety of capacities. Not only was he an outstanding baseball player, he was also a sportswriter for several local publications, including the *Midget Martínez' Sport Page*. He was commissioner of the East Los Angeles Baseball League, sponsored by American Legion Post 804. The post was named after Eugene Arnold Obregón, who was killed in action in Korea and posthumously received the Congressional Medal of Honor. (At right, courtesy of Mimi Poon Fear; below, courtesy of Henry R. Mendoza.)

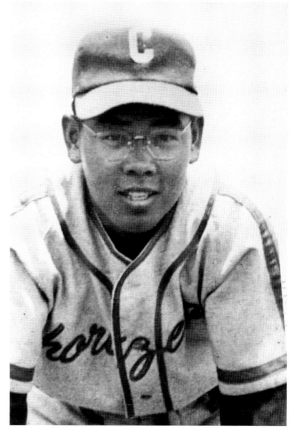

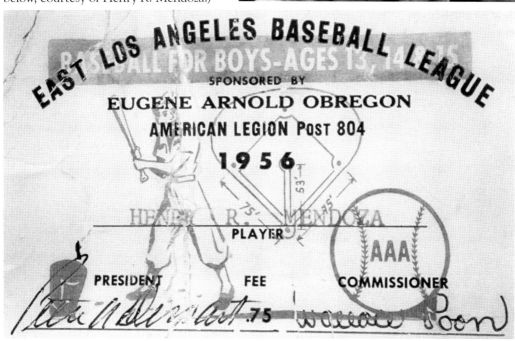

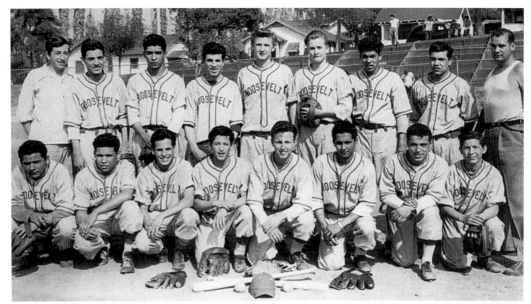

The 1947 varsity baseball team at Roosevelt High School in East Los Angeles included two of the famous Peña brothers, John (second row, second from right) and Richard (first row, second from right), both of whom played professionally. Al Padilla (first row, second from left) played at Occidental College and later coached baseball and football at Roosevelt and Garfield High Schools and East Los Angeles College. Their legendary manager was Joe Gonzales (second row, far right), who played for the Boston Red Sox. (Courtesy of Richard Peña.)

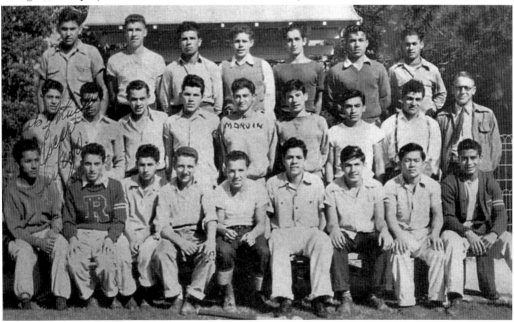

The 1943 Roosevelt High School softball team featured several outstanding players, including Ernie Sierra (first row, second from left), Raul Rejalado (first row, far right), Tony Serrato (second row, third from right), and George Peña (third row, second from right). Many of these players would later serve during World War II. (Courtesy of Carlos and Rachel Santillan.)

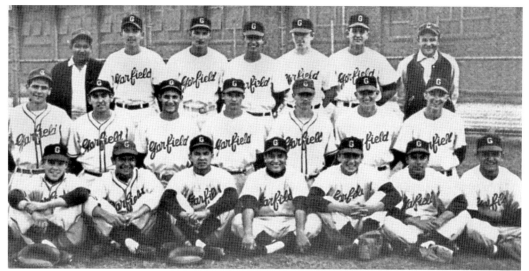

The archrival of Roosevelt High School, Garfield High School's baseball team won the 1952 and 1956 Los Angeles City championships. The 1954 Garfield High School team (shown here) won the Southern League championship and had many talented players, including Ernie Valenzuela, Tom Robles, Al Tafoya, Fred Scott, Angel Figueroa, Ernie Negrete, Rudy Castillo, and Bill Miranda. (Courtesy of Fred Scott.)

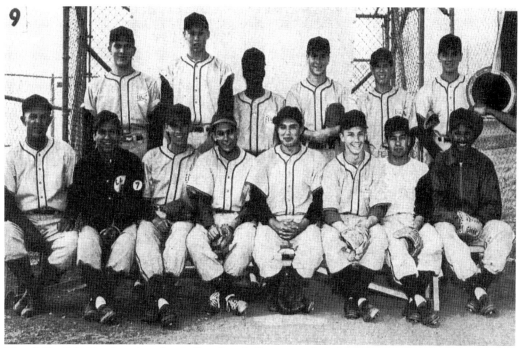

The 1953–1954 East Los Angeles College baseball team included local players from both Roosevelt and Garfield High Schools, several of whom attended the college under the GI Bill. Marcelino Saucedo (first row, third from left), Joe Gaitán (first row, second from right), Bobby Garcia (first row, far right), and Bobby Recendez (second row, second from right) were among the Mexican Americans on the roster. (Courtesy of Marcelino Saucedo.)

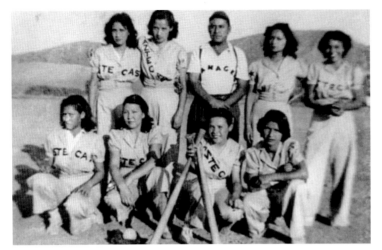

Mexican American women's softball teams were formed throughout California and the United States. Young Mexican American women asserted cultural pride through team names, such as the 1936 Las Aztecas team of Los Angeles. One of their outstanding players was Delia Ortega (second row, second from right). (Courtesy of Sandra Uribe.)

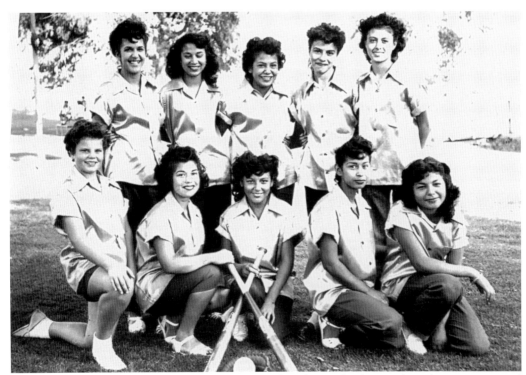

The 1950–1951 East Los Angeles Columbianas played at Belvedere Park and were sponsored by the Columbia Utility Company in Los Angeles. The team was comprised of girls around 15 years old, most who knew each other from Kern Avenue Junior High School and Garfield High School. Like many girls' teams, there were several sets of sisters and cousins who played together. Jo (Galindo) O'Dell (second row, far left) played catcher and right field. Jo's father, Sammy Galindo, played baseball in East Los Angeles for years. (Courtesy of Jo Galindo O'Dell.)

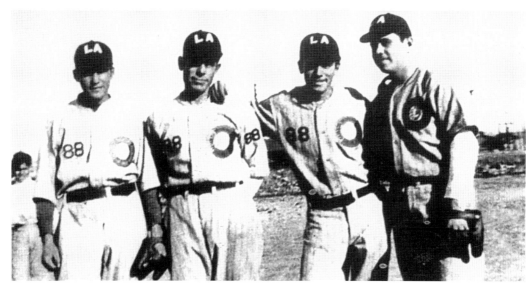

It was not unusual to have several brothers on teams because of the large Mexican families and their love of baseball. In 1932, the Armenta brothers (from left to right, Oscar, Paul, Tony, and Ray) developed their skills and passion for the game as members of La Alianza Mexicana, a mutual aid society–sponsored team based in Los Angeles. Mutual aid societies promoted civil, political, economic, and legal rights for Mexican Americans. There were hundreds of these organizations in the United States in the 1930s. (Courtesy of Bea Armenta Dever.)

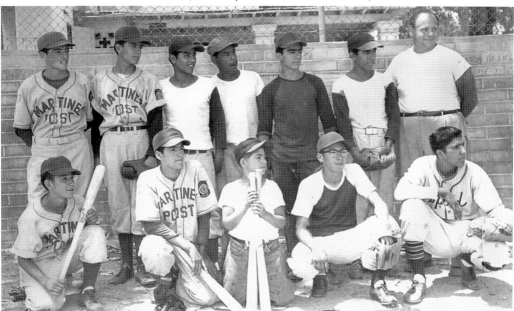

Sponsored by the American Legion, the Jose P. Martínez Post 623 team included three sets of brothers: Conrad (second row, far left) and Joe Munatones (first row, second from left), Ernie (first row, far left) and Ruben Rodríguez (second row, second from left), and Gilbert (first row, far right) and Tony Gámez (batboy, first row, center). Jose P. Martínez, a farm laborer from New Mexico, was the first Mexican American to be awarded the Congressional Medal of Honor during World War II. Martínez received the award posthumously. (Courtesy of Gilbert and Alma Gámez).

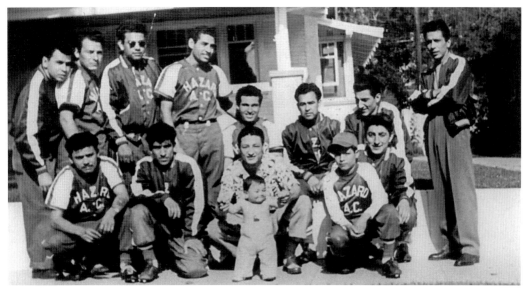

During the 1940s and 1950s, neighborhood athletic clubs flourished in East Los Angeles and other California Mexican American communities. Some of the players were returning veterans, and many were married, raising families, and had full-time jobs. The Hazard Athletic Club (around 1949) was managed by Pete Navarro (standing, far right). The man holding the child is Enrique Bolanos, the great Mexican American boxer. (Courtesy of the Navarro family.)

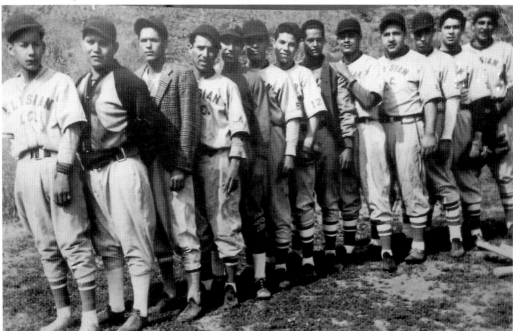

In the early 1940s, the Elysian Athletic Club represented Chávez Ravine, the Mexican American community in Elysian Park, where Dodger Stadium is currently located. Baseball was popular in the neighborhoods of Chávez Ravine in the years before residents were forcefully displaced from their homes. Manuel "Shorty" Pérez (second from left), who went on to manage the Carmelita Chorizeros for 35 years, was player-manager for the Elysian Athletic Club.

There were hundreds of Mexican American players who brought immense joy and honor to their Los Angeles neighborhoods. Pedro Barrios Sr., nicknamed "Pete Viejo" (Old Man Pete), lived in East Los Angeles and played with the Moctezuma Athletic Club and other teams. This c. 1921 photograph was taken at a ball field that was eventually destroyed to make way for the San Bernardino Freeway into downtown Los Angeles. (Courtesy of Pete Barrios Jr.)

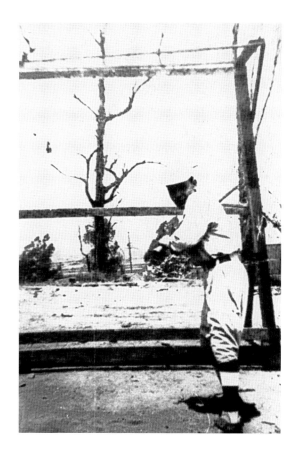

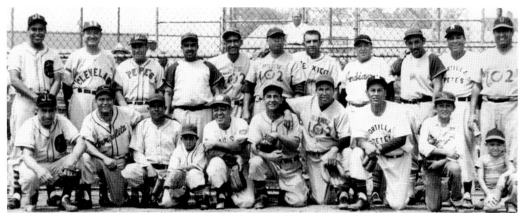

A legendary baseball promoter, Manuel Regalado selected this East Los Angeles All-Star Team for a 1956 game against a team from El Paso. The uniforms show some of the local sponsors that supported these players, including Carmelita, Brew 102, Tortilla Pete's, and Pepe's Pirates. Manuel Regalado, in the second row, second from left, is wearing a Cleveland Indians uniform courtesy of his son Rudy, who played in the major leagues. Shorty Pérez, the celebrated manager of the Carmelita Chorizeros, is seen first row, second from left. (Courtesy of Ron Regalado.)

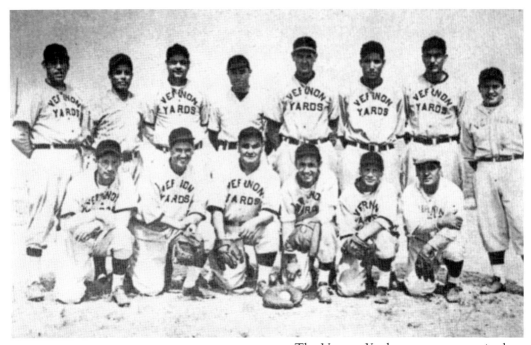

The Vernon Yards team was comprised of players who were maintenance workers or drivers for the Los Angeles Transit Line's streetcars during World War II. Being a good ballplayer was often a ticket to employment. Companies took pride in winning, and Mexican Americans succeeded in playing on highly rated teams in the industrial and agricultural leagues throughout California. Joe Miranda (first row, second from left) was one of the stars of the Vernon team in the early 1940s. (Courtesy of Bill Miranda.)

Marcus Torres was a standout baseball player at Redondo Union High School from 1940 through 1944. This 1946 photograph was taken while he played minor-league professional baseball in Reno, Nevada. (Courtesy of "Chuey" Hernandez.)

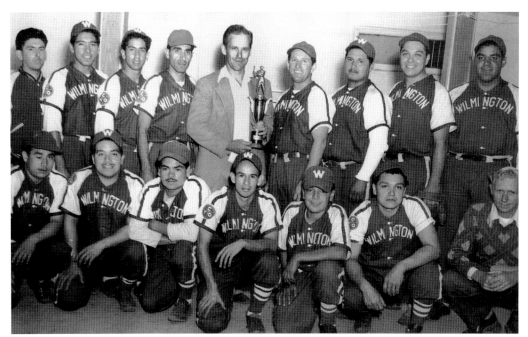

The 1940s Catholic Youth Organization (CYO) team in Wilmington won several league championships. Many of its players later had important careers outside of baseball. Henry Manzo (first row, third from right) became an attorney, and Tony Manzo (first row, second from right) became general superintendent of the Long Beach Shipyard. Charlie Rico (second row, second from right) became an instructor at Los Angeles Harbor College. (Courtesy of Ramon Quesada.)

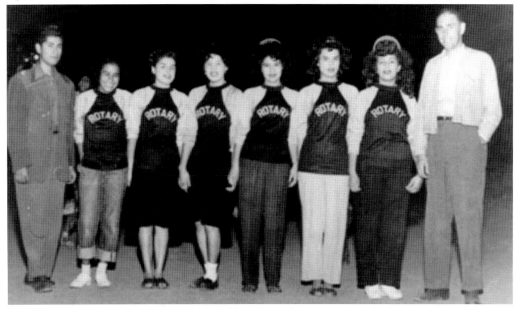

Similar to men's teams with several sets of brothers, the San Fernando Rotary women's team of 1943 included two pairs of sisters: Tiny (third from left) and Barbara Orduno (third from right), and Ramona (fourth from right) and Lucy Fonseca (second from right). As with most women's teams of their era, the coaches and managers were men. (Courtesy of Sandra Uribe.)

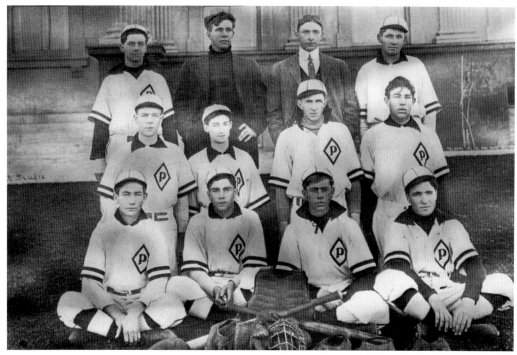

Born in San Pedro in 1893, Louie Sepúlveda (first row, second from left) excelled in baseball at San Pedro High School. He played professionally with the San Francisco Seals for five years as a catcher. In 1917, he ended his baseball career to serve in the Navy during World War I. Like his father, Don Roman Sepúlveda, Louie was a respected benefactor to the people of San Pedro. Today, the Sepúlveda name remains well known for their many contributions to the Harbor communities of Los Angeles. (Courtesy of the San Pedro Historical Society.)

Tony Gamboa played third base for several teams in Los Angeles, most notably the El Paso Shoe Store, which fielded some of the best teams during the 1920s and 1930s and played many games at White Sox Park. So popular was Gamboa that he was issued a police card from the chief of police. Gamboa reportedly went to a tryout for the Brooklyn Dodgers and was told by a Dodger official not to waste his time because major-league baseball did not want Mexicans. (Courtesy of Vivienne Ryan.)

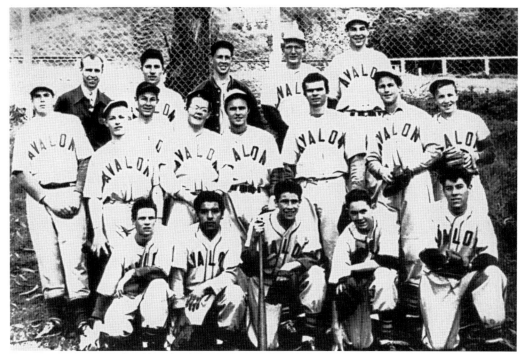

The Avalon High School baseball team of 1952 played their games at Wrigley Field on Catalina Island. The team benefited from pitching, hitting, and fielding tips provided by the Chicago Cubs, who held spring training on Catalina Island for many years. The team included brothers Camilio (third row, center) and Ernie Machado (second row, third from left), John Hernández (first row, second from left), Marcelino Saucedo (first row, center), and Frank Saldana (first row, far right). (Courtesy of Marcelino Saucedo.)

The 1959 Irwindale Clovers, like many teams of its era, had several brothers and cousins who played together. The Clovers ranged from 13 through 18 years of age and featured the Chico clan: Rueben, Bobby, and Johnny. Art Tapia Jr. (second row, fourth from left) played in the military while stationed in Korea in 1963. John Hernandez (first row, far left) still plays senior slow pitch in Anaheim. (Courtesy of Art Tapia Jr. and John Hernandez).

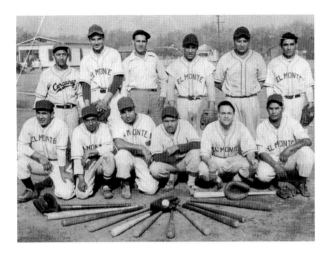

The city of El Monte has a long history of Mexican American baseball. Fidel Soliz (first row, far right) was a shortstop, pitcher, and catcher for a team in the segregated neighborhood known as Hicks Camp. Like many players of his generation, Fidel was a World War II veteran. After the war, he played baseball on the weekends and softball during the week. Another El Monte neighborhood that produced several outstanding teams and players was Medina Court. (Courtesy of Lucy Vera Pedregon.)

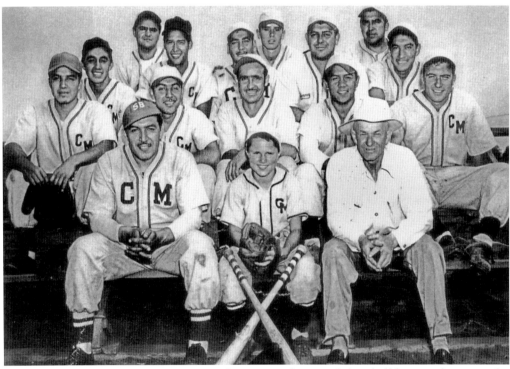

The Mexican American community in Carpinteria has a rich baseball history dating to the 1920s. Many of the players worked in the packinghouses and citrus fields. The 1947 Carpinteria Merchants featured players such as Eddie Arellano (fourth row, far left), Dan Manríquez (third row, far left), Joe "Pops" Granada (second row, far left), and Reg Velásquez (second row, second from left). The Merchants played into the 1970s and were led by John Moreno, a star on the Carpinteria High School baseball team, which won the school's first California Interscholastic Federation championship in any sport. (Courtesy of S. Jim Campos.)

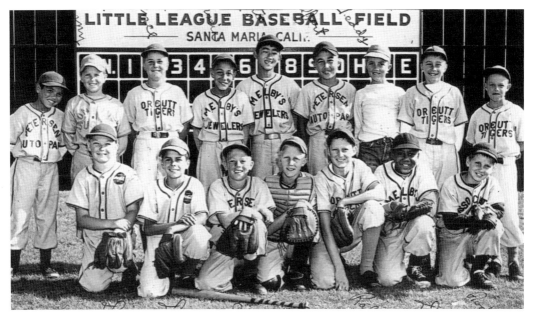

In 1950, the first Little League–chartered all-star team from Santa Maria and Orcutt featured several Mexican Americans, including Richard "Ducky" Ramos (first row, second from left), Gil Higuera (second row, fourth from right), Peter Lucero (second row, far left), and Ernie Corral (second row, fourth from left). Corral, along with Eddie Navarro, are actively involved with preserving the sports history of Santa Maria. (Courtesy of Eddie Navarro.)

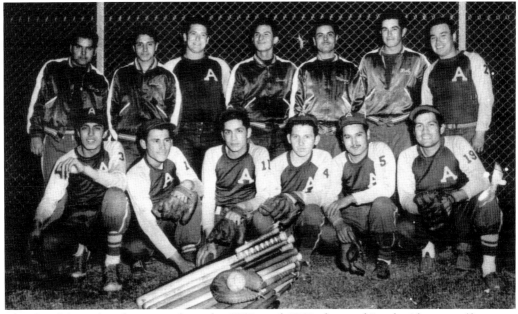

The Guadalupe Apaches team from the 1950s and 1960s featured Lindy Almaguer (first row, far right), John Alvarado (first row, far left), Ray Antunez (first row, third from left), Joe Lemos (second row, second from left), and Skippy Zepeda (second row, third from left). The team was a member of the Guadalupe League and played on the first lighted field in the area. (Courtesy of the Guadalupe Cultural Arts and Education Center.)

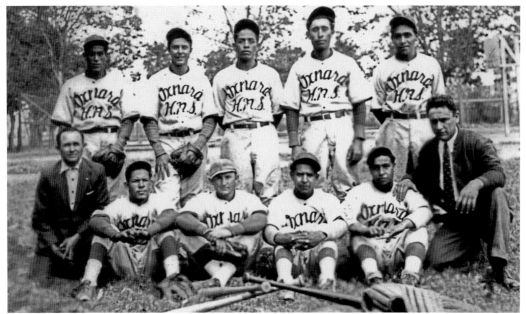

Mexican Americans settled in Ventura County in several communities, including Ventura, Santa Paula, Camarillo, and Oxnard, and worked in the citrus fields, packinghouses, railroads, sugar refineries, rock quarries, and fisheries. Like so many Mexican American communities, residents quickly established baseball teams. This photograph from the 1930s depicts the Oxnard Aces, who played on the same field that the New York Giants and Chicago White Sox played on in 1913 in an exhibition game. (Courtesy of Jeffrey Maulhardt.)

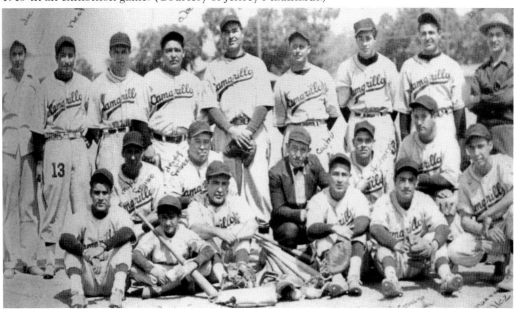

The 1950 Camarillo Merchants featured several outstanding players, including brothers and cousins Chapo Hernández, David Velásquez, Joe Velásquez, Genaro Ayala, Demetrio Ayala, Manuel Tellez, Mike Franco, Johnny Franco, Abe Franco, Nestro Alvarez, Joe Sanchez, Manuel Ortiz, and Louis López. (Courtesy of Jeffrey Maulhardt.)

One of the top semiprofessional teams in California was the 1939 Pismo baseball club, which competed for the state championship in Torrance. There are at least three Mexican Americans on this team, including Marky Aguirre (first row, far left) and Marty Martínez (second row, third from right), both from Santa Maria. Earl Escalante (first row, far right), of San Luis Obispo, went on to play for the Hollywood Stars in the Pacific Coast League. The Central Coast had several Mexican American teams or Mexican American players on Anglo teams. (Courtesy of Eddie Navarro.)

The 1934 Riverbank Merchants team played in a small community next to Modesto. Mexican roots run deep in Riverbank, with most people tied to the agricultural industry. Like many other California Mexican American communities, residents faced discrimination in housing, education, employment, and recreation. Banned from the city swimming pool, Mexican children swam in the river and canals. Baseball was an escape from the harsh conditions of racial exclusion. (Courtesy of Felix Ulloa.)

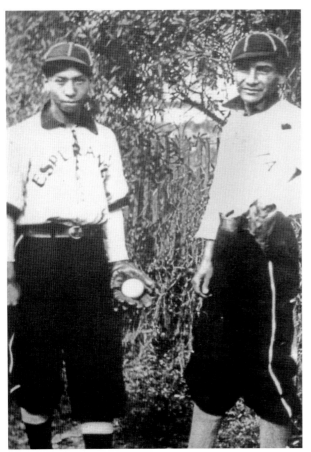

In 1909, the multicultural Esperanza team of Pasadena—the term *esperanza* means "hope" in English—included Francisco Chávez (right), who was a plumber by trade. Francisco was born in Queretaro, Mexico, in 1880 and entered the United States in 1895. He married California native Inez Trujillo-Mendibles in 1901 and settled in Pasadena. Esperanza's well-attended baseball games were held on a diamond south of California Boulevard near Lake Avenue. (Courtesy of Mary Ann Montañez.)

The Mexican American community of La Rambla in San Pedro fielded a team called Atlas during the early 1930s. Two players have Cubs uniforms that may have been hand-me-downs from the Chicago team, which had training facilities at nearby Catalina Island. The manager was José "Joe" González (first row, far left). Next to him is brother Andrés "Andy," and brother Pedro "Pete" is in second row, far right. (Courtesy of Gilbert González.)

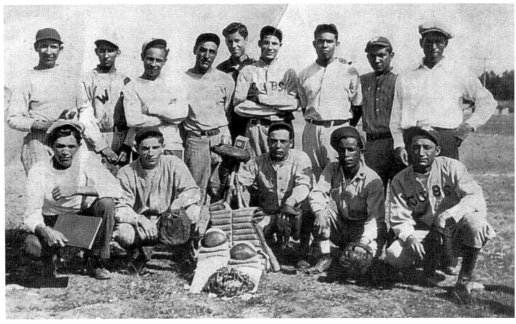

Mexican American Baseball

The San Bernardino Valley

The San Bernardino Valley consists of San Bernardino, Highland, Redlands, Colton, Bloomington, Grand Terrace, Loma Linda, Fontana, and Rialto. The largest Mexican community within the Inland Empire during the 20th century could be found in the western end of the city of San Bernardino along Mount Vernon Avenue. Route 66's placement along Mount Vernon Avenue assisted in sustaining Mexican American–owned businesses, many of which went on to sponsor local barrio baseball teams, such as Mitla Café's legendary night softball teams and the Manny Chavez–sponsored team simply known as Manny's. In addition, companies that employed Mexican workers supported teams such as the Santa Fe Tigers, sponsored by the Santa Fe Railroad depot, and the East Highland Aztecs, backed by the East Highland Orange Company. San Bernardino's Mitla Café proved to be a force in Southern California barrio baseball and fast-pitch softball, as the team won three consecutive city league titles from 1947 to 1949 and featured star players such as ace pitcher Johnny Gonzalez, the Botello brothers (Lin, Joe, and Ralph), Cruz Nevarez, and Ray Perez.

Colton also produced a force in Southern California Mexican American baseball in the Colton Mercuries (at times also spelled *Mercurys*), a team famous for winning a large number of league titles. The Mercuries helped produce Inland Empire baseball hero Camilo Carreon, who eventually played for the Chicago White Sox, Cleveland Indians, and Baltimore Orioles. Furthermore, women also organized teams, such as the intercommunity team known as the Cherokees that consisted of players from Colton, San Bernardino, and Riverside. The Colton Mercury Señoritas and San Bernardino Raiderettes were also visible on the baseball diamond. Women utilized baseball to publicly display athletic talent and often formed female support networks through the sport. The Catholic Church also figured prominently in Mexican American baseball, as it sponsored teams to prevent delinquency among Mexican youth—proving especially significant as Mexicans were segregated from municipal parks, public pools, theaters, schools, and labor until the late 1940s. For the Mexican communities of the San Bernardino Valley, baseball served as an essential vehicle to foster community and ethnic pride.

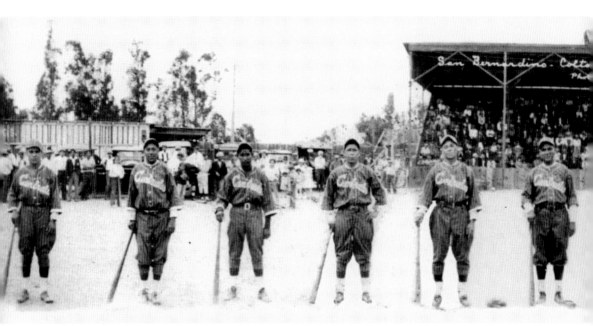

The San Bernardino–Colton Centrals pose at Cubs Park, also known as El Corralón (the Corral), in South Colton, in April 1930. Owned by entrepreneur and team sponsor Juan Caldera, El Corralón served as a multipurpose recreational site for Mexicans in Colton with a community swimming

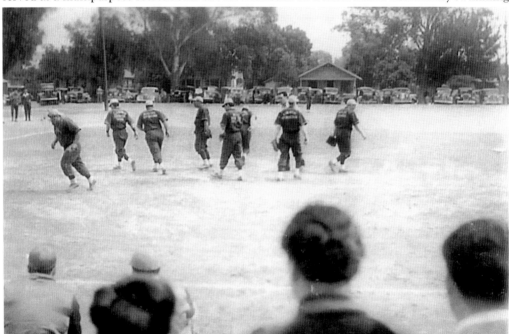

Games played at Seventh Street and Mount Vernon Avenue in San Bernardino would draw thousands of fans on any given day. Enthusiastic supporters arrived early and lined the outfield with their cars to get the best view. When players launched home runs, these fans would honk their horns in celebration. Around 1945, this unnamed team takes the field as spectators from the San Bernardino barrio look on.

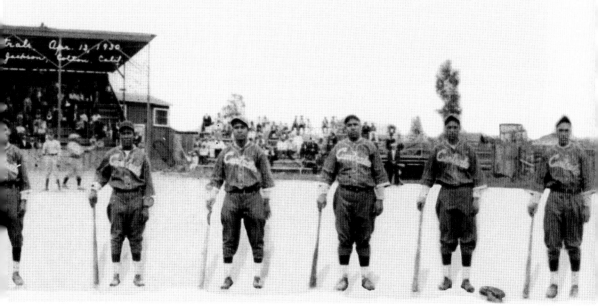

pool, boxing facilities, and a baseball diamond. El Corralón proved to be especially important during this era, as Mexican Americans were segregated from Anglo recreational sites.

This picture was taken in 1937 in Colton's La Paloma barrio. Ernie Garcia (at bat) and Ray Abril Jr. started playing as soon as they could pick up a bat—eventually playing for the Junior Mercuries during the 1940s. Mexican Americans involved in baseball often learned leadership skills through the sport. Abril supported higher education for Mexican Americans in his adult career as a Colton School Board member and dedicated his life to ending institutional discrimination against Mexicans in Colton. Garcia eventually earned his doctorate degree in 1969 and became dean of the College of Education at California State University, San Bernardino.

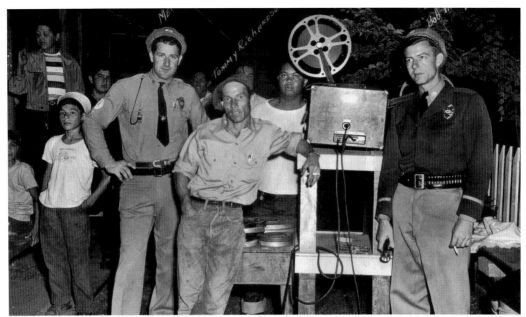

Tommy Richardson (above, leaning on projector) and Chevo Martinez (below, second row, far left) played instrumental roles in establishing Mexican American baseball teams in the 1940s by clearing fields for baseball diamonds and recruiting players for community teams in San Bernardino and Colton. Richardson, an ardent community activist, is pictured at one of his backyard film screenings for the youth of the Mexican community. As an employee for city parks and recreation, he constantly pressured San Bernardino's city council to desegregate public parks and pools, as Mexicans could only attend the plunges one day out of the week. Martinez stands with members of the Santa Fe Tigers, East Highland Aztecs, and Colton Mercuries. San Bernardino's Sal Saavedra (below, kneeling, center) and Johnny Gamboa (below, kneeling, right) became renowned barrio baseball and softball players in the San Bernardino Valley.

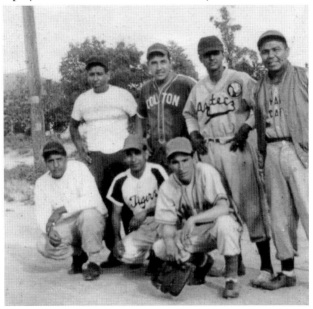

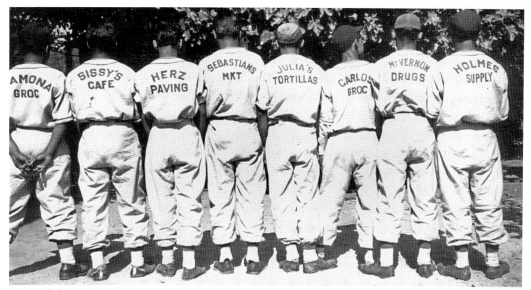

Around the mid-1940s, members of the San Bernardino Guadalupe baseball team proudly display their local business sponsors on the back of their uniforms. Teams often depended on community support to survive, as local, Mexican-owned businesses funded many baseball clubs. Sponsors would provide funds for uniforms, field maintenance, and equipment. Other forms of financial support came through individual donations by "passing the hat" during baseball games. Although this team was sponsored by San Bernardino's Our Lady of Guadalupe Church, members still found additional sponsors, such as Julia's Tortillas, Ramona Groceries, Mount Vernon Drugs, Carlos' Groceries, Sissy's Café, and Sebastian's Market. Golden Glow Beer sponsored this early-1940s American Legion 709 team (below) posing in front of Colton's Gate City Wine and Beer.

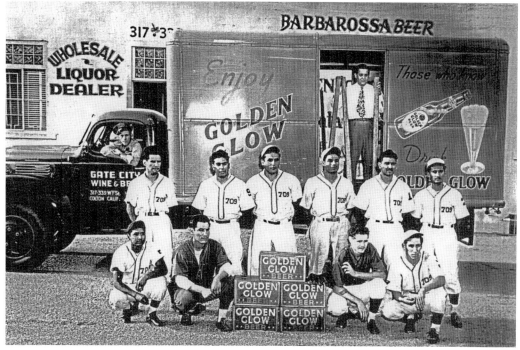

MEXICAN AMERICAN BASEBALL IN THE INLAND EMPIRE 31

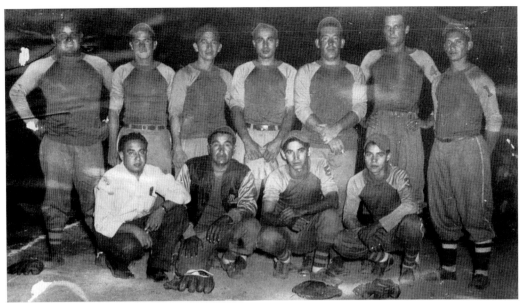

Church sponsorship was crucial for the development of Mexican American teams. Above, this Redlands Catholic Youth Organization of 1940 featured Harry Muñoz (kneeling, third from left), one of the best players in the region, who eventually signed with the St. Louis Browns in the mid-1940s. Below, Fr. Jose Nuñez (front row, right), of Our Lady of Guadalupe, stands next to Mayor James E. Cunningham (center) and San Bernardino city attorney T.C. Perry (left) with five church-sponsored teams around 1947. Combating delinquency among Mexican youth served as one of Padre Nuñez's primary objectives for the Mount Vernon barrio. Nuñez encouraged baseball for Mexican youth, because it promoted solidarity and leadership skills. Baseball proved to be an integral political space for Mexican Americans in San Bernardino, as Nuñez, Tommy Richardson, and other Westside community leaders initiated a successful court case against the City of San Bernardino to desegregate parks and recreational facilities for Mexicans in 1944.

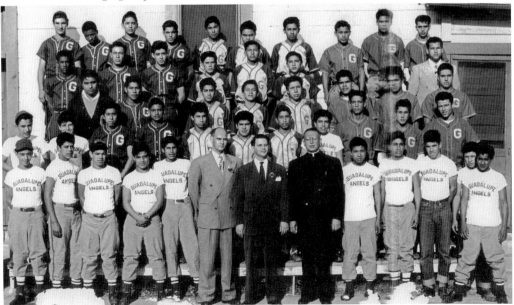

Women were not excluded from the national pastime. Born in Eastland, Texas, in 1924, Carmen "Carmie" Lujan moved to Colton when she was three years old. Starting at the age of 12, she played with the Colton Mercury Señoritas from 1936 to 1939. Gabe Castorena coached the Señoritas and eventually became manager for the Colton Mercuries. Other players for the Señoritas included Luz Arredondo, Chita Garcia, Mary Soto, Mary Rivas, Stella Pimentel, Mary Rosales, and Betty Caldera.

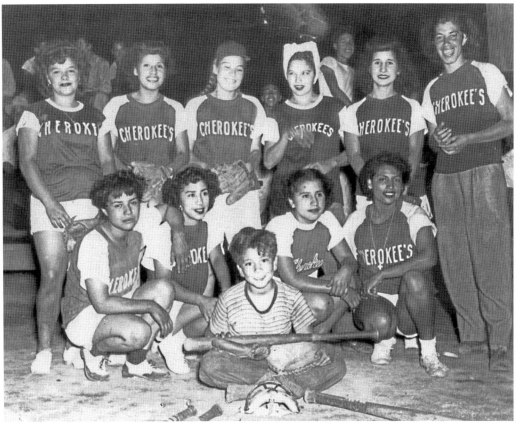

Seen around 1946, this all-women's Cherokees softball team was composed of players from Colton, San Bernardino, Riverside's Casa Blanca barrio, and Belltown in west Riverside. Players for the Cherokees included Carmen Lujan and Betty Caldera (of Colton), Chita Garcia and Emma Galvan (of Casa Blanca), and Stella Peña, Margarita Peña, and Paulina Espinoza (of Belltown).

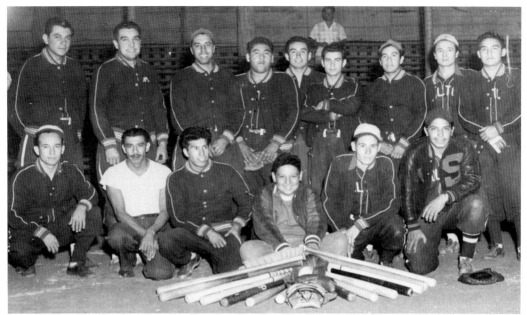

Around 1945, the Colton Mercuries softball team played night games against teams like San Bernardino's Mitla Café. Colton versus San Bernardino games would draw thousands of fans, as these two communities held a long-standing rivalry dating back to the early 20th century. From left to right are (first row) Fred Vasquez, Pete Luque, Charlie Martinez, Tudy Rodriguez, Mike Mercado, and Joe Castañon; (second row) Tony Garcia, Baker Martinez, Willy Rueda, Pat Carranza, Gabe Castorena, Robert Rosales, Teyo Duarte, Ralph Martinez, and Johnny Mejia. Aside from playing with the Mercuries, Gabe Castorena co-managed the all-female Cherokees team during the 1940s. Tony Sanchez (below, second row, third from the left) also co-managed the women of the Cherokees team. In addition to displaying their athletic talents, these women utilized baseball and softball to forge female support groups.

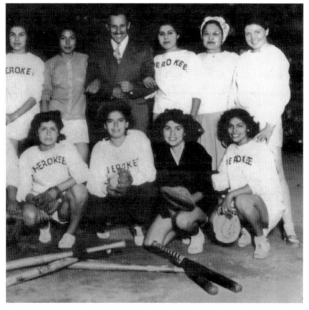

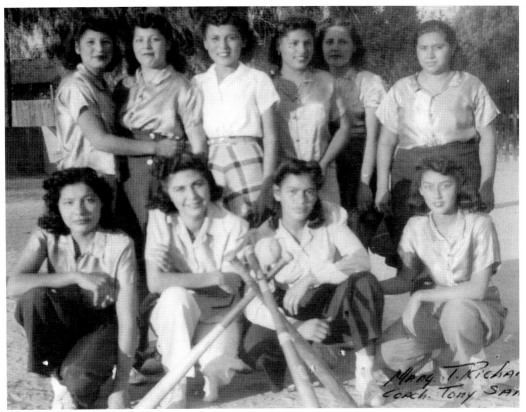

This San Bernardino women's team from the 1940s (above) poses for a photograph at the baseball diamond on Seventh Street and Mount Vernon Avenue. The San Bernardino Raiderettes of Our Lady of Guadalupe (below) pose for a team portrait in the 1950s. The Raiderettes, who played at Our Lady of Guadalupe's parking lot on Fifth Street and Pico Avenue, competed against teams from various Inland Empire barrios, including Casa Blanca in Riverside. For many of the women involved, baseball offered a public vehicle to display athletic talent, competitive spirit, and an opportunity to be seen outside of the home. The Raiderettes include, from left to right, (first row) Virginia Villareal, Mary Lou Lopez, and Tillie Villegas; (second row) Dolly Villegas, "Chris" Lopez, Lynn Vasquez, an unidentified priest and coach, Armida Neri-Miller, Juanita (surname unknown), and Angie Garcia.

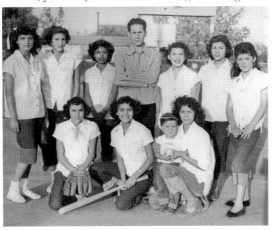

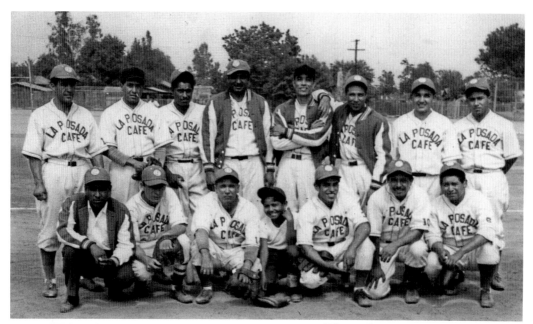

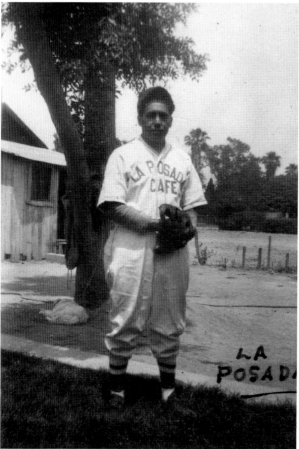

The mid-1940s La Posada Café Aztecas team shown here became the first Mexican baseball and softball team to enter the City League of San Bernardino. The original 1940 La Posada team encountered many obstacles and much ridicule, as it was the only team in the City League without uniforms—most players wore only a T-shirt with a large A on the front to identify themselves. Despite encountering hardships, this team organized by Tommy Richardson became the first to win the City League championship in its inaugural year of competition. That same year, La Posada also won the Southern California Mexican Athletic Association title by ousting Macy's Cubs of Los Angeles and the Santa Monica Aztecas at White Sox Park in Los Angeles. La Posada did not receive a trophy for winning the tournament, as each member only received a popsicle and a watermelon. Joe Botello (left) proudly wears his La Posada uniform.

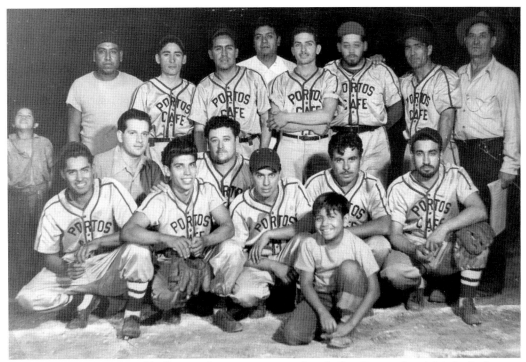

The 1947 Porto's Café softball team, later co-sponsored with San Bernardino's Mitla Café, won three consecutive City League championships from 1947 to 1949. The brilliant managerial talents of Chevo Martinez (second row, far left) helped develop Porto's into a Southern California baseball and fast-pitch softball force, as the San Bernardino team traveled as far as Anaheim and Los Angeles to compete in, and often win, tournaments in these regions.

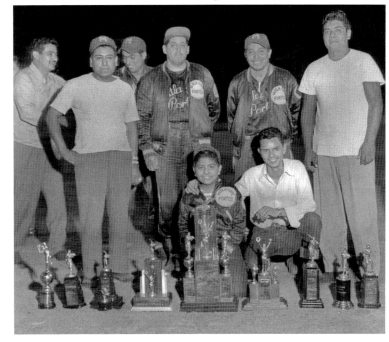

Johnny Gonzalez (center with upturned cap), star pitcher for Mitla Café's softball team, poses in front of the team's impressive collection of trophies. Over the course of Mitla Café's successful three-peat dynasty, Gonzalez proved to be nearly unhittable throughout Southern California. Manager Chevo Martinez (second from left, white shirt and M on hat) would eventually depart Mitla Café after the 1949 season to manage the Colton Mercuries.

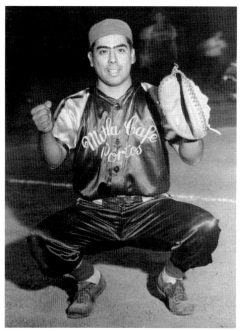

Cosponsored by Mitla Café and Porto's Café, the San Bernardino City League championship team eventually came to be called the Mitla Café Portos. Established in 1937 along Route 66 on Mount Vernon Avenue, the Mitla Café is the oldest Mexican restaurant in the Inland Empire and one of the oldest Mexican restaurants in the United States. Mitla Café is still open for business and is a San Bernardino Mexican cultural institution. Ralph Botello poses in his Mitla Café Portos uniform.

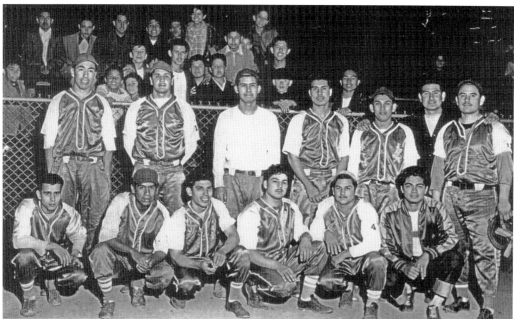

The 1948 La Cabaña championship baseball team poses while celebrating at Seventh Street and Mount Vernon Avenue. La Cabaña represented the next generation of San Bernardino baseball, as the team served as a community "farm team" for developing talent. This effort to produce new talent out of the barrio displays the permanency and cultural force that baseball engraved on the Mexican community. From left to right are (first row) Ray Perez, Joe Delgado, Larry Trujillo, Richard Negrete, Lalo Bettencourt, and Richard Casillas; (second row) Chuey Mendoza, Tony Cano, Manuel Leon, Morrison Aguila, Sal Saavedra, Joe "Maestro" Martinez (manager), and Marcelo Dominguez.

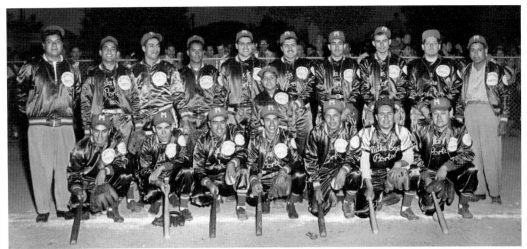

City Champions Mitla's Café are seen above in 1949. From left to right are (first row) Lin Botello, Richard Gamboa, Ralph Botello, Larry Trujillo, Joe Castañon, and two unidentified; (second row) manager Mike Martinez, Cruz Nevarez, Ralph Lopez, Robert Mancha, Raul Adame, Teo Adame, Sal Rodriguez, Fred Arcy, Johnny Gonzalez, manager Chevo Martinez. Cruz Nevarez proudly served in the US Army during World War II, became San Bernardino's first Mexican American schoolteacher, and founded San Bernardino's chapter of the Community Service Organization (CSO). From left to right, CSO president Nevarez is pictured below with secretary Daniel Landeros, treasurer Helen Martinez, and Industrial Areas Foundation field director Fred Ross. San Bernardino's CSO provided citizenship classes and voter registration for Mexican Americans. During the 1950s, Ross brought a young Cesar Chavez to work with Nevarez in San Bernardino prior to his involvement with the United Farm Workers. (Courtesy of Carmen Dominguez-Nevarez.)

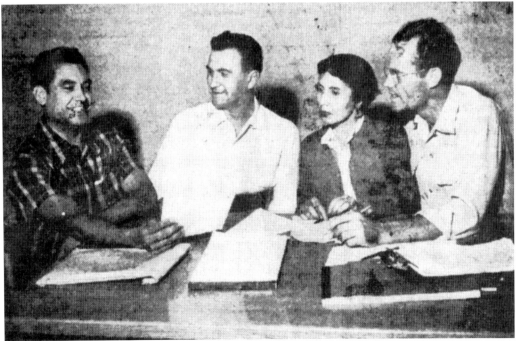

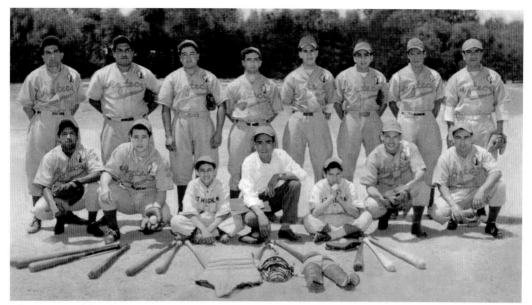

The East Highland Aztecs pose above for a team portrait at the old East Highland ballpark off Greenspot Road around 1948. This team featured players from the East Highland barrio known as El Ranchito and was sponsored by employer the East Highland Orange Company. From left to right are (first row) Vince Padilla, Fred Paramo, Richard Aguilar (batboy), Paul Delgado (manager), Tony Paramo (batboy), Saturnino Paramo, and Tim Delgado; (second row) David Sloriano, Nacho Mendoza, Joe Mesa, Art Gonzalez, Robert Ballesteros, Monte Resendez, John Ramos, and Manuel Ballesteros Sr. In the c. 1964 image below, the East Highland Aztecs continue with a new generation of players. From left to right are (first row) Ray "Monce" Mendoza, Richard Paramo, John Alvino, Frank Aguilar, Manny Ballesteros Jr., Richard Aguilar, and David Paramo; (second row) David Chavez, Danny Cruz, Freddy Cruz, Sam Paramo, Ernie Paramo, Nelo Humildad, Kenny Barajas, Robert Ballesteros, and Eddie Ybarra.

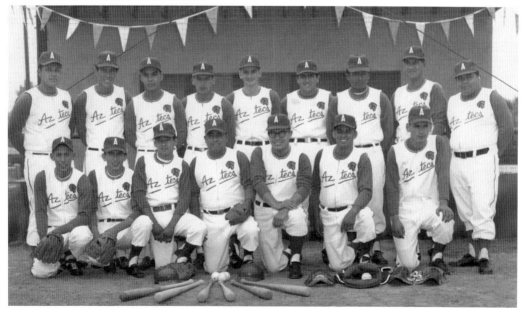

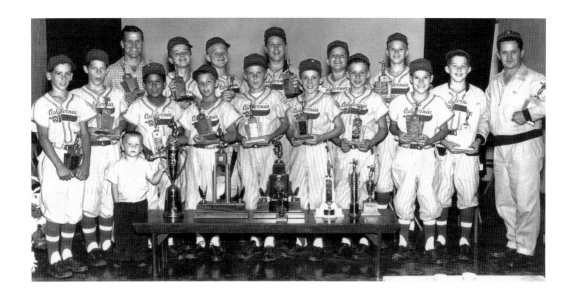

Above, Danny Carrasco (first row, third from right) and Chon Calderilla (first row, third from left) were members of the Colton team that reached the 1954 Little League World Series Finals in Williamsport, Pennsylvania. Below, while in Williamsport, the Colton Little League team had the opportunity to meet Hall of Fame pitcher Cy Young (center). Chon Calderilla (front, holding glove), Danny Carrasco (to the right of Young, smiling), and future 1962 National League Rookie of the Year Kenny Hubbs (directly above Danny) are seen with Young. Carrasco recalls that Little League exposed him to new experiences and opportunities outside of the Colton barrio, such as traveling across the nation by train.

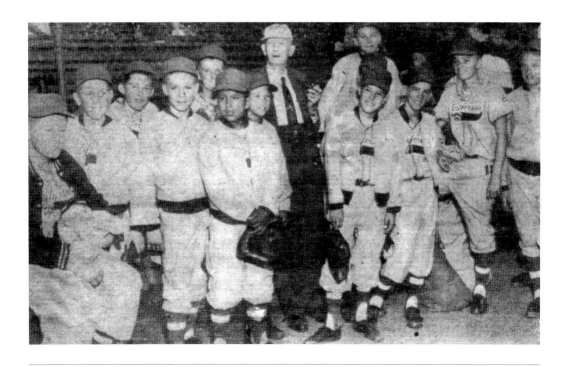

Danny Carrasco and Chon Calderilla continued their baseball careers into high school with the Colton Yellow Jackets. Calderilla is shown at left in his Yellow Jackets uniform. Danny (first row, fourth from right) is shown below with the 1961 varsity team at Colton High School. From left to right are (first row) manager T. Eyler, T. Wood, S. Hartford, J. Smith, W. Thornton, D. Carrasco, T. Housley, T. Krachovil, and manager A. Aparicio; (second row) coach T. Hoy, M. Mullins, N. Taylor, J. Magness, J. Cross, M. Kaiser, R. Quarles, T. Lambeth, L. Matus, and coach T. Verbantz.

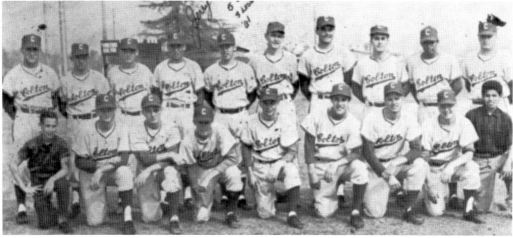

Bobby Carrasco (right) played on the varsity baseball squad for the Colton High School Yellow Jackets. During the 1950s, Bobby founded the Sunset League, one of the most significant Mexican American baseball associations in Southern California. The Sunset League included teams like Manny's of San Bernardino, the Colton Mercuries, Corona Athletics, and Cucamonga Browns. Colton High School also produced Camilo Carreon, a legend in the Inland Empire for his superb athletic talents that eventually carried him to play in the major leagues as a catcher for the Chicago White Sox. Carreon (first row, third from right) is shown with the junior varsity squad at Colton High School.

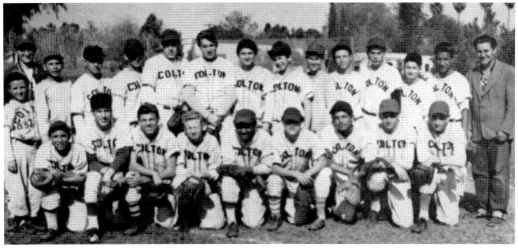

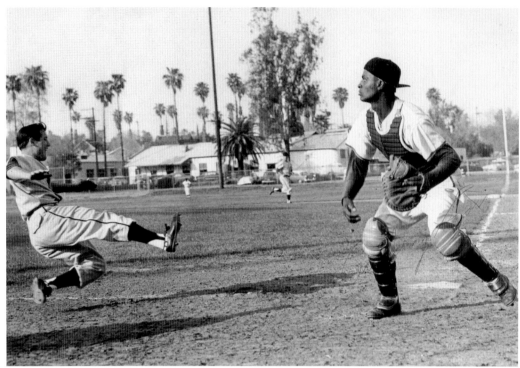

Pete Carrasco slides into home as a member of the 1958 San Bernardino Valley College Indians. Many Mexican Americans involved with baseball took their athletic talent from the barrios onto the college baseball diamonds. The sport often assisted players at excelling beyond the baseball field as students, community members, and educators. Danny and Pete Carrasco eventually became part of California State University, San Bernardino's first graduating master's class in 1973.

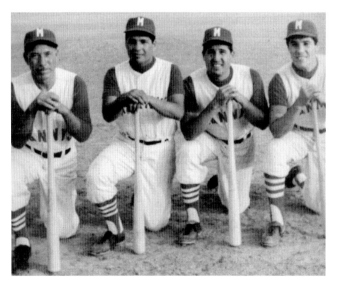

The Carrasco family, of Colton, exemplifies the various ways in which baseball unified Mexican families in the Inland Empire. From left to right are Robert Carrasco Sr., Robert "Bobby" Carrasco Jr., Pete Carrasco, and Danny Carrasco. The love of the game was often passed down from fathers to sons. Shown here in their Manny's of San Bernardino uniforms, the Carrasco family made a winning team not just on the baseball field, as the Carrasco brothers excelled as community members by coaching baseball and serving as educators.

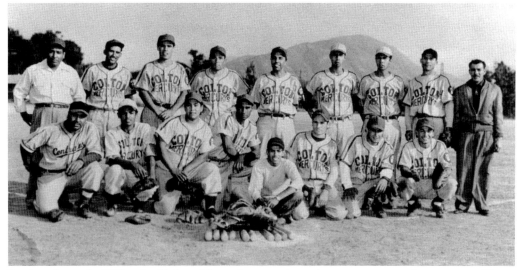

During the early 1950s, the Colton Mercuries experienced great success under manager Chevo Martinez (second row, far left), winning three straight league titles. This team featured players such as Teyo Duarte, Ralph Martinez, Manuel and Ernest Abril (*los cuates,* or "the twins"), Frank Acosta, and Ambrocio Gonzalez. The photograph was taken at Veterans Park in Colton around 1951.

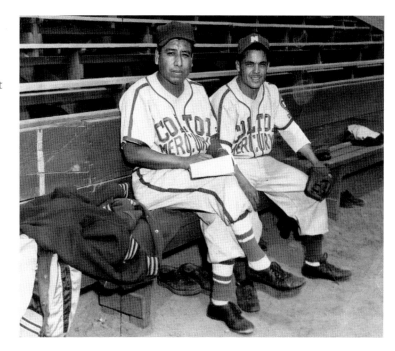

Colton Mercuries manager Chevo Martinez (left) sits next to one of the team's best players, Frank Acosta, as they make pregame preparations. This photograph was taken in May 1951 at Perris Hill Park as the Mercuries made their way up in the Sunset League standings. Chevo always made time for baseball despite working full-time at the Santa Fe Railroad yard as a machinist making only 35¢ an hour.

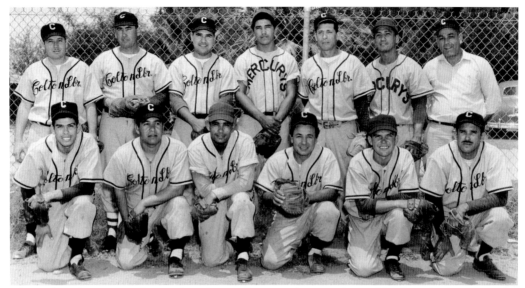

The Colton Mercuries also produced major-league talent in players like Camilo Carreon, who eventually played several years for the Chicago White Sox. Manager Chevo Martinez (not pictured) also had success versus professional teams, as he once beat and held the Pittsburgh Pirates scoreless with a San Bernardino-Colton all-star team at Perris Hill Park. From left to right are (first row) Manuel Suchil, Teyo Duarte, Willie Gomez, Ralph Martinez, Jim Bartho, and Dynamite Suchil; (second row) Mike Mercado, Art Miguel, Rudy Alba, Camilo Carreon, Ambrocio Gonzalez, Ray Martinez, and Joe Gomez.

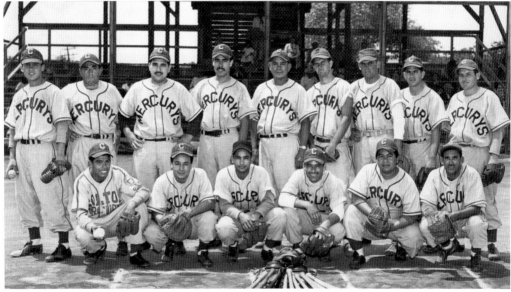

The Colton Mercuries are pictured around 1954. Look closely for announcer Rufas Gonzalez, as he is sitting in the box behind the bleachers. Prior to each game, during warm-ups, Gonzalez would play Mexican boleros, such as Los Dandys, to entertain the crowd and players. From left to right are (first row) Manuel Suchil, Ralph Martinez, Willie Gomez, Lalo Gomez, Teyo Duarte, and Albert Suchil; (second row) Hank Gonzalez, unidentified, Rudy Alba, Dave Beltran, Sisto Armenta, three unidentified, and Mike Mercado.

Chevo Martinez had a knack for recruiting talent for the teams he managed. Martinez would scout at local high schools for upcoming talent but also managed to recruit established players from nearby communities. Art Miguel, pictured here at Perris Hill Park in San Bernardino, was a longtime player for the Corona Athletics but also played under Chevo for the Colton Mercuries.

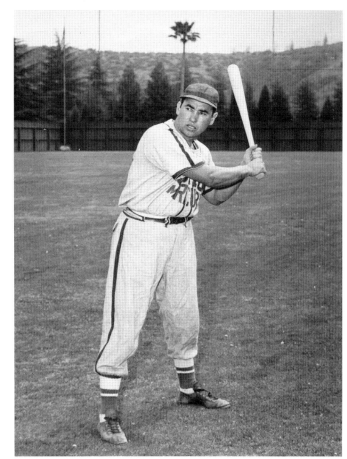

The San Bernardino Centrals from 1953 featured talent such as Chuey Mendoza (second row, third from left), who sustained an illustrious baseball career in the Inland Empire. The Centrals were yet another team that Chevo Martinez (first row, second from left) managed throughout his long baseball career. In addition, the Centrals featured several African American ballplayers.

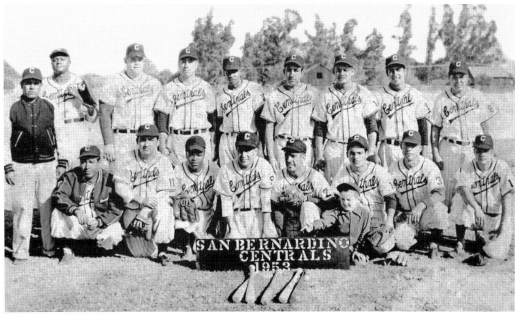

MEXICAN AMERICAN BASEBALL IN THE INLAND EMPIRE

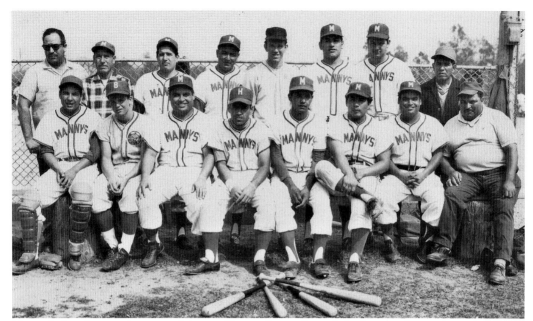

Named after the team's sponsor Manny Chavez (second row, left, donning his trademark shades), Manny's baseball team from San Bernardino won several Sunset League titles during the 1960s. If the team won games, Chavez would often treat the players to drinks at his bar located on Mount Vernon Avenue. This 1963 photograph features, from left to right, (first row) manager Robert Carrasco Jr., unidentified, Joe Acosta, Felix Gomez, Manuel Martinez, Alex Rubalcava, Jess Acosta, and Pete Mata; (second row) Manny Chavez, Robert Carrasco Sr., Pete Carrasco Sr., Ralph Montano, unidentified, Chuck Acuna, Bobby Cruz, and Ysidro Suarez.

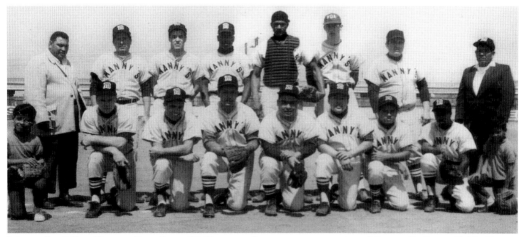

Manny's of San Bernardino from 1966 poses for a team portrait at Nuñez Park on Fifth Street and Medical Center Drive. From left to right are (first row) Kenny Acosta (batboy), Ray Schmidt, Frank Acosta, Manuel Martinez, Joe Acosta, Chris Laguna, Joe Ortiz, "Schmitty" Schmidt, and Joe Acosta Jr. (batboy); (second row) Pete Mata (grounds/equipment manager), Pete Carrasco, Danny Carrasco, Paul Porter, Noland Hill, Greg Schaffer, Norman Nelson, and Ruben Suarez Sr.

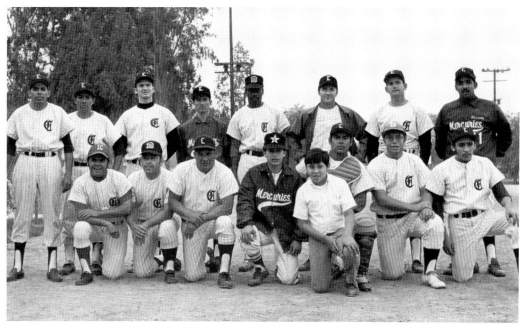

This Colton Mercuries team from the 1960s was famous for winning the Sunset League championship after being three games down and coming back to win four straight games. In his first season with the Mercuries, Jim "Chayo" Rodriguez (first row, third from left) served as player-manager. Others on the Colton Mercuries included Tom Mercado, Martin Vivar, Jerry Leon, Gil Ayala, Rudy Ahumada, Dennis Speier, John Sierra, Xavier Castro, Gabe Mercado, Lucio Perez, and Papo Jaurigue.

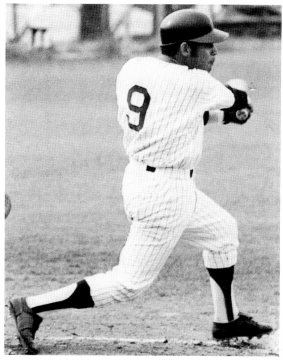

Ronald Cabrera, of Colton, is shown slapping a base hit while playing for UC Riverside's baseball team in 1971. During this season, while playing at the fifth-annual National Invitational, Cabrera was voted all-tournament third baseman and was the only Mexican American on the team. Cabrera also excelled in the Sunset League playing for the Colton Mercuries, San Bernardino Padres, Flamingos, and the 888s.

Baseball played a major role in nurturing leadership and organizational skills for its players. Joe Baca (second row, second from right, smiling with SB cap), congressman for California's 43rd Congressional District, was a member of the San Bernardino Aztecs. Chris Laguna (first row, left), of San Bernardino, also played for the Aztecs. This image was taken at Encanto Park on Kent Street and Mount Vernon Avenue around 1972.

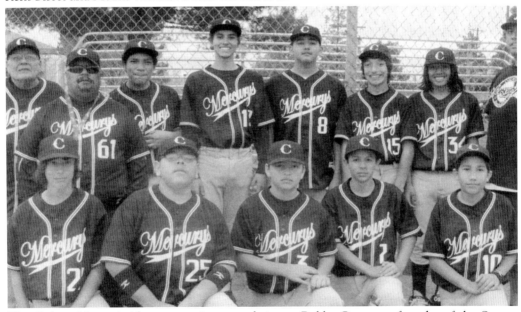

The Colton Mercuries' legacy continues to thrive as Bobby Carrasco, founder of the Sunset League during the 1950s, resurrected the team during the 2000s. Members of this Mercuries squad include grandchildren of former Colton Mercuries players. Carrasco's dedication to preserving the game has ensured that the next generation of players can enjoy the benefits that past players experienced.

Mexican American Baseball

Corona, Riverside, and the Coachella Valley

Taken from Jose Alamillo's *Making Lemonade Out of Lemons*, Natividad "Tito" Cortez recalls his playing days with the Corona Athletics and offers insight into the relationship between labor and leisure: "Working inside the [citrus] groves, carrying a heavy sack, climbing up and down the ladder, using a quick eye to pick lemons helped with my pitching and [baseball] training. Everyone used to comment how we would work like a dog all week picking lemons, then played baseball all day on Sundays. But you see, that was the only thing to do since there was no television."

This chapter looks at the Mexican American baseball teams of Riverside County and the Coachella Valley. Formed in 1933 by Mexican American youth who labored in Corona's citrus fields, the Corona Athletics eventually became one of the Inland Empire's premier baseball clubs by winning numerous local league championships. Several major-league baseball teams even recruited various members of the Corona Athletics to play professionally, such as Natividad "Tito" Cortez, Remi Chagnon, Bobby Perez, Ray Bega, and Ray Delgadillo. Women's teams, such as Las Debs de Corona and the Busy Bee's of Riverside's Casa Blanca barrio, also made their way onto the diamonds to display their athleticism and competitive spirit.

After World War II, Mexican American veterans on Riverside's Casa Blanca Aces team proudly displayed their military belts as part of their baseball uniforms. Displaying military belts on the baseball diamond served as a powerful statement for members of the Casa Blanca Aces to declare their equality against long-standing social discrimination and segregation. Mexican American teams in the desert communities of the Coachella Valley also figured prominently in the realm of baseball. Mexican Americans often lived on the Indian reservations of Palm Springs and Coachella; however, these communities still formed their own women's and men's teams. For example, Palm Springs' "section fourteen" barrio located on the Agua Caliente Indian Reservation formed a team simply known as the Mexican Colony to compete against other local baseball clubs. Moreover, the Valdivia family, of Beaumont, formed an impressive baseball dynasty that still resonates today.

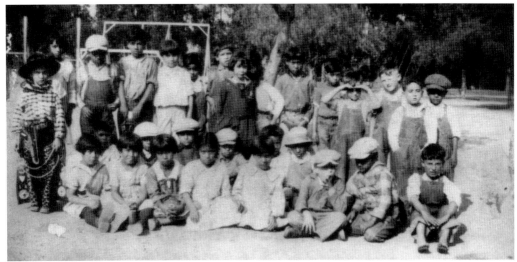

Corona's Washington Elementary School appears around 1925. Segregation for Mexicans existed in nearly every societal aspect, including politics, housing, labor, and education. Mexican children were de jure segregated from Anglos until the late 1940s. Sixth Street divided Mexicans living on the north end of Corona from Anglos living on the south side of town. Most original Corona Athletics ballplayers attended Washington Elementary School in northern Corona. Above, Natividad "Tito" Cortez (back row, sixth from right) and Ray Delgadillo (back row, fifth from right) were among the first members of the Corona Athletics during the 1930s and were eventually recruited by major-league teams. Below, Mexican immigrants and their children mainly worked as pickers within Corona's citrus industry. Pictured here are Mexican pickers and Anglo foremen at the Corona Foothill Ranch around the 1920s.

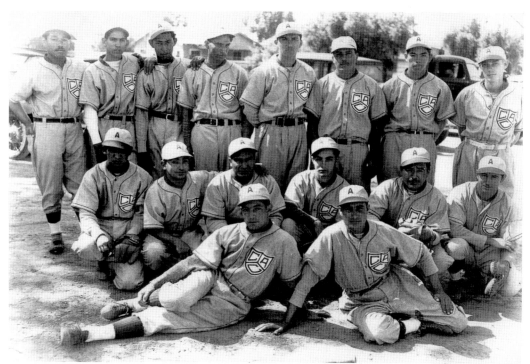

The 1939 Corona Athletics featured players like Ray Delgadillo (third row, second from right) and Tito Cortez (third row, third from left), who displayed outstanding talent but were not allowed to compete professionally with Anglos because of major-league baseball's racial restrictions. It was not until 1947 when Jackie Robinson broke the color barrier with the Brooklyn Dodgers that more Mexican Americans made their way into professional baseball. Delgadillo, Remi Chagnon, and Tito Cortez were recruited to play for major-league farm teams between 1947 and 1949.

This Corona Athletics player poses in front of Corona's Santa Fe Railroad depot in 1937. Segregationist policies within city parks and recreational facilities forced Mexicans to find other spaces to play their games. The Athletics, who transformed an empty railroad yard in the Corona barrio into a baseball diamond, relied on the Mexican community's financial support to play their games and maintain their field after many players decided to break away from inadequate company sponsorship.

Ray Delgadillo played with the Corona Athletics from the 1930s through the 1950s. Aside from playing barrio baseball, Delgadillo also competed in Mexico, in college, and in the military during World War II. Shown here in the uniform of the Riverside City College Tigers during the late 1940s, Delgadillo joined the team at the age of 30 after serving in the war. While playing for the Tigers, Delgadillo made the all-conference team and was one of the college's most experienced players.

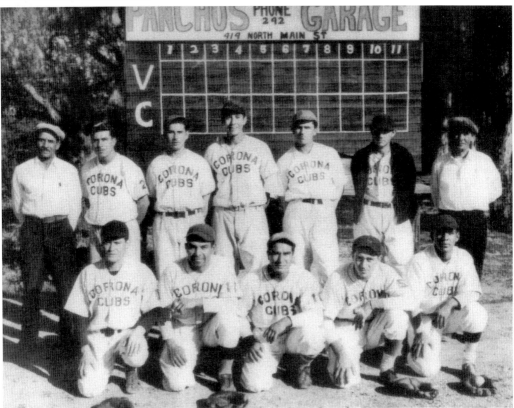

Although baseball established bonds of male camaraderie between Mexican Americans, some players' defiant attitudes led to divisions. In 1946, the Corona Cubs were organized after one Athletics player was benched for missing numerous practices and displaying rowdy conduct during a game. The disgruntled Athletics player eventually left the team and persuaded others to join him in forming the Corona Cubs to rival the Athletics. This version of the Cubs played at Corona City Park and was sponsored by Pancho's Garage. From left to right are (first row) two unidentified, Sammy Rodriguez, Henry Uribe, and unidentified; (second row) Marcelino Barba, Manuel Contreras, Neto Ramirez, Remi Chagnon, John del Campo, and two unidentified.

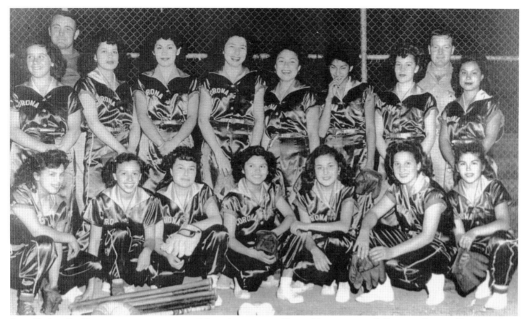

Las Debs de Corona was sponsored by American Dry Cleaners and featured an all–Mexican American roster in April 1949. Marcos Uribe, former Corona Athletics manager, helped organize the team. From left to right are (first row) Ruth Martinez, Gloria Mendoza, Yolanda Bravo, Dolores Delgadillo, Annie Hernandez, Rosa Enriquez, and Catherine Delgadillo; (second row) Norma de Leo, Margaret Zarate, Angie Flores, Dora Mendoza, Annie Bravo, Socorro Garcia, Ramona Galvan, and Doris Arrendondo; the men in back are unidentified.

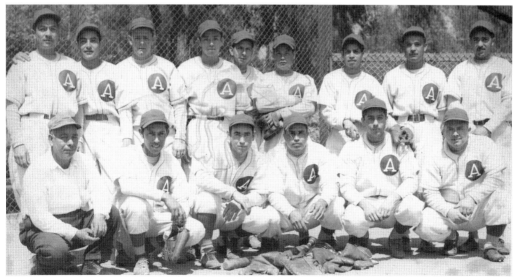

Shown around the mid- to late 1940s, this Corona Athletics team features future professional player Tito Cortez (first row, second from left) and Ray Bega (second row, sixth from left), who was offered a minor-league contract but could not sign, as he was underage and had familial obligations. The Athletics were a force in Inland Empire baseball, as they frequently won league championships during their heyday. Most importantly, the Athletics served as a means to foster community and ethnic pride for Mexicans in Corona.

Pitcher Tito Cortez shined for the Corona Athletics from 1939 to 1947. During his tenure with the Athletics, Cortez, whose signature pitch was a curveball, tossed an incredible five no-hitters. He eventually signed with the Cleveland Indians in 1947 at 28 years old, the same year that Jackie Robinson broke the color barrier in major-league baseball. Cortez contended that his pitching abilities developed while working in the citrus fields, as the intense labor served to condition his body and develop hand-eye-coordination skills.

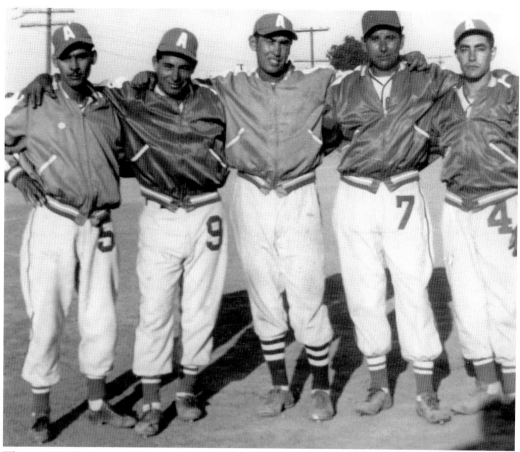

The c. 1948 Corona Athletics team seen above includes, from left to right, Frank Uribe, Frank Gomez, Art Miguel, Neto Ramirez, and Alfredo Uribe. Art Miguel, also pictured at right, was a senior member of the Athletics, as he played over a decade for the team. Miguel, who was part Native American, played outside of Corona as well, eventually landing on the Colton Mercuries club under manager Chevo Martinez in the early 1950s. Many former Athletics players fondly remember Miguel, including Corona legend Jim "Chayo" Rodriguez, who named his annual softball tournament in Art's honor. Miguel's connections to Colton and other Mexican communities in the Inland Empire demonstrate the social-networking strength that baseball provided Mexican American players throughout the region.

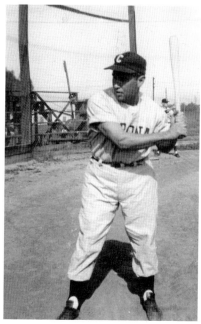

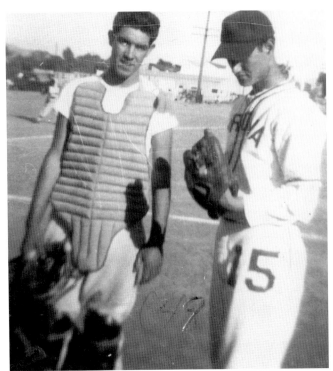

At left, brothers Joe (left) and Carlos Uribe are pictured while playing for the 1948 Corona Athletics. Carlos's talents allowed him to join a veteran Athletics club as a teenager in high school in 1947. Members of the same family often formed Mexican baseball teams, and rosters frequently displayed identical surnames multiple times. Carlos, also pictured below, and Joe Uribe were just two of six brothers who eventually became members of the Corona Athletics. Like many other Mexican American baseball players, Carlos eventually served his country by fighting in the Korean War. While stationed in Seoul, Korea, he also played for the 504th Signal Battalion's baseball team.

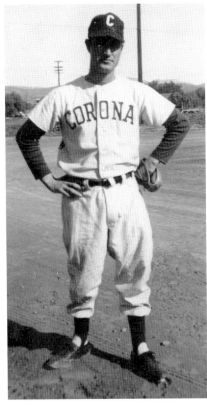

Joe Uribe, of the Corona Athletics, demonstrates his batting stance at the team's home field, which was situated between Sheridan and Railroad Streets and Corona Boulevard. Despite having scant financial resources, players did what they could to maintain their home field. They often recall the poor conditions of the playing surface and hated sliding into the bases because of the rough terrain; however, players fondly remember the baseball diamonds for their priceless memories. Alfredo Uribe (below, kneeling) was the eldest of the Uribe brothers and was among the first Corona Athletics players.

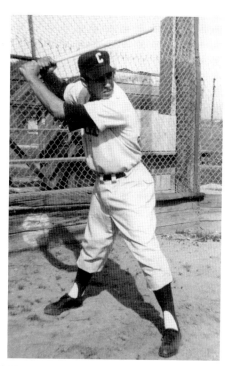

Mitch Salgado demonstrates his batting stance in his Corona Athletics uniform. Like Carlos Uribe and Ray Delgadillo, Salgado served in the US military. A medic in the Army from 1952 to 1954, Salgado returned from the Korean War as a decorated veteran, having received various medals, including the Bronze Star. Salgado is shown here at the Athletics' home field, where he once dodged a few cars on Grand Boulevard to catch a fly ball.

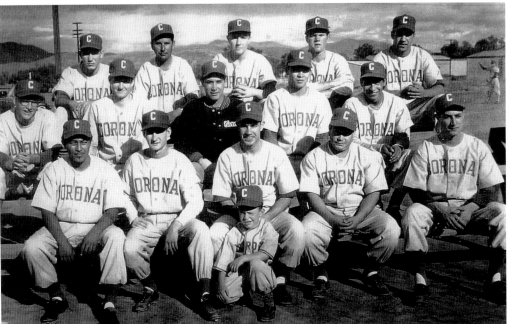

In 1954, as veterans of the Athletics retired, manager Jess Uribe (second row, black jacket) integrated the predominantly Mexican American team with Anglo ballplayers. Ray Bega (first row, second from right), Carlos Uribe (first row, far right), and Bobby Perez (second row, second from right) were scouted by major-league teams with Uribe and Perez eventually signing professional contracts. This team also featured Corona baseball legend Jim "Chayo" Rodriguez (second row, far right) in addition to Neto Ramirez, Jose and Luis Uribe, Jerry Delmont, Bobby Sturk, Jess Arellano, and John, Jim, and Sammy Ragsdale.

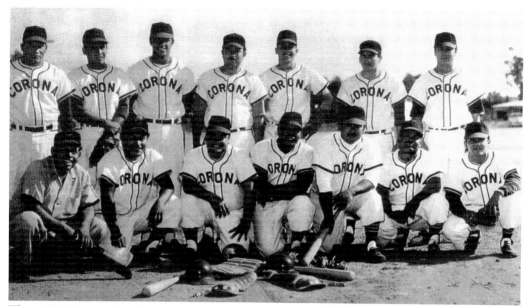

This 1950 Corona Merchants squad poses for a team portrait. Manager and team founder Jim "Chayo" Rodriguez (second row, far left) began playing baseball with the Corona Athletics in 1942 at the age of 13. From the 1940s through the early 1970s, while Chayo was distinguishing himself on the Inland Empire's baseball diamonds, he was also actively playing and promoting fast-pitch softball. Some of the fast-pitch softball teams Chayo played for during that time included the American GI Forum, Jalisco Café, and Mona's Café.

Perhaps Chayo Rodriguez's greatest association in baseball was with the Chicanos, a team that he founded in 1973 and would manage for 17 years. During the heyday of the Chicano Movement, Chayo decided to form a fast-pitch softball team whose purpose was to redirect the energies of at-risk Mexican American youth from criminal activities to athletic pursuits. While the Chicanos' home field was Corona City Park, the team traveled extensively, playing top-notch competition in tournaments in Palm Springs, Santa Barbara, and even Yuma, Arizona.

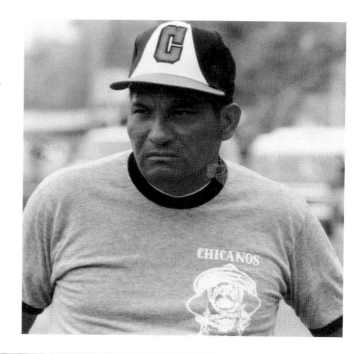

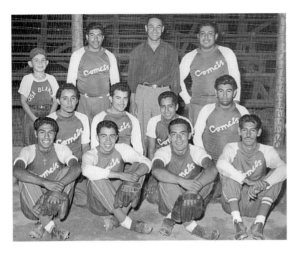

Around the mid-1940s, this Casa Blanca Comets team of Riverside was managed by Ernie Benzor (third row, second from right). Casa Blanca first emerged as a barrio in the early 20th century as Mexican immigrants settled permanently in this Riverside neighborhood to labor in the nearby citrus fields. From left to right are (first row) Nick Aparicio, Rudy Alfaro, Albert Jaramillo, and Victor Aparicio; (second row) John Torres, Robert Olvera, Pete Castro, and Alvina Aparicio; (third row) Joe Conejo (batboy), Frankie Torres, Ernie Benzor, and Tommy Valterria.

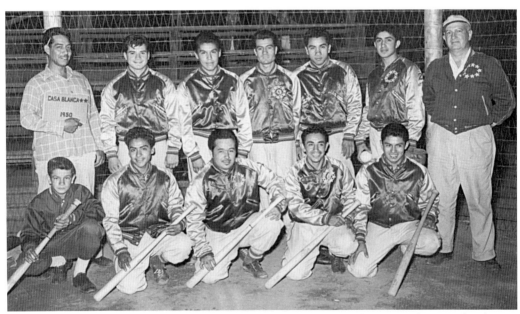

The 1950 Casa Blanca Stars of Riverside appear at their home field at Casa Blanca School, or as many in the Mexican community remember it, the "Escuela Vieja" ("Old School"). Casa Blanca School operated as a segregated Mexican school until the late 1940s. From left to right are (first row) Red Morales (batboy), Magdaleno Pena, Manuel Negrete, Alex Benzor, and Aurelio Alfaro Jr.; (second row) Aurelio Alfaro (scorekeeper), Lupe Raya, Victor Perez, Leo Galvan, Manuel Gomez, Eddie Martinez, and manager Mr. Madden.

The Casa Blanca Busy Bees fast-pitch softball team played from 1945 to 1950 against women's teams from Colton, Ontario, Corona, and San Bernardino. The Busy Bees are shown here at Escuela Vieja in Casa Blanca. Emma Galvan was a high-profile softball pitcher and proved to be nearly unhittable within the region. From left to right are Stella Galvan, Mary Louise Gutierrez, Jessie Gutierrez, Mercy Chavez, Emma Galvan, Vera Rodriguez, Jenny Gomez, and Kinny Galvan.

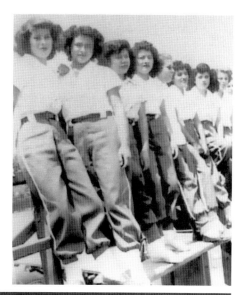

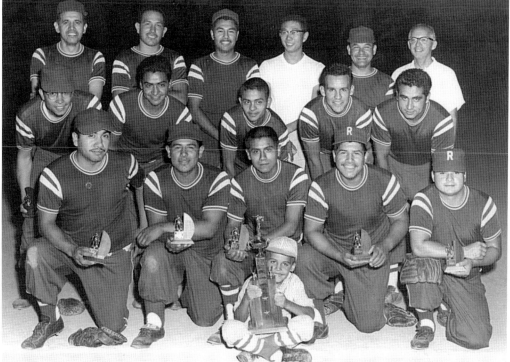

The 1957 Casa Blanca Vagabundos, sponsored by Richard's Jewelers, pose with their Riverside City League championship trophies at Villegas Park. It was not uncommon for other kids from non-Anglo ethnic groups to play with Mexican American teams. For example, Kangi Gotori (third row, third from right with white shirt) was Japanese American and played for the Vagabundos. From left to right are (first row) Eddie Benzor (batboy); (second row) Manuel Gomez, Rudy Chavez, Manuel Mendoza, Tony Chavez, and Lupe Raya; (third row) Ernie Ramirez, Magdaleno Pena, Frankie Villegas, Ed Robles, and Chayo Negrete; (fourth row) Manuel Galvan, Cornelio Velasquez, Nick Aparicio, Kangi Gotori, Ernie Benzor (manager), and an unidentified sponsor from Richard's Jewelers.

Sal Valdivia Sr., of Beaumont's south-side barrio, was a member of the Beaumont High School baseball team in 1944. In 1948, Valdivia started Los Amigos, the barrio's first fast-pitch softball team that still exists today. Despite Valdivia's talents as a football, baseball, basketball, and track athlete, Anglo players refused to shake his hand after games because he was Mexican. Like many other Mexican ballplayers, Valdivia went on to serve the community, eventually becoming a city council member from 1972 to 1976. (Courtesy of Sal Valdivia Jr.)

This 1968 Mt. San Jacinto Junior College baseball team featured Sal Valdivia Jr. (second row, third from left), Butch Murphy (second row, fourth from left), and Sam Racadio (second row, far right). Half Irish and half Mexican, Murphy grew up on the Pechanga Indian Reservation and was the first varsity baseball coach at Murietta Valley High School. Racadio became the first city manager of Highland and also served as a Highland City Council member.

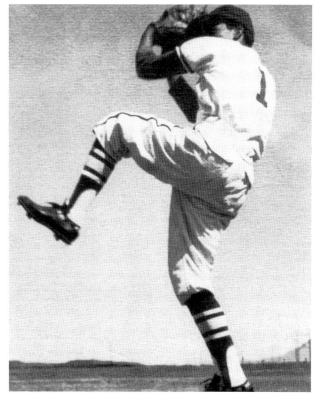

The Valdivia family was the recipient of an incredible three straight Most Valuable Player awards at Beaumont High School from 1962 to 1964. Taking the honors were David (1962 MVP, above, left), Robert (1963 MVP, above, right), and Sal Valdivia Jr. (1964 MVP, at right). Robert was an outstanding fast-pitch softball player as well, and he once hit a home run off Eddie "The King" Feigner—who earned fame for striking out, in order, Willie Mays, Willie McCovey, Brooks Robinson, Maury Wills, Harmon Killebrew, and Roberto Clemente. David, Robert, and Sal were all inducted into the Southern California Latino Native American Sports Hall of Fame. Until this day, the Valdivia family holds various sports records at Beaumont High School. In addition, Sal Jr. also won MVP honors in basketball and football. (Courtesy of Sal Valdivia Jr.)

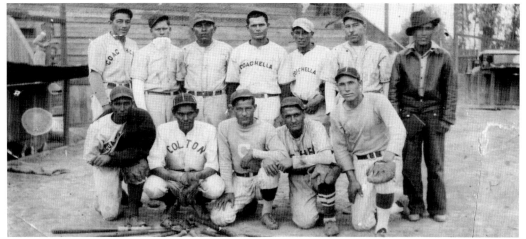

Members of the Coachella Tigers and Colton Mercuries pose before a game in Coachella around the early 1930s. Many teams created networks in the Inland Empire through labor and familial connections. For example, Roberto "Beto" Carrasco, of Colton (kneeling, far right), often worked with Ramon "Zurdo" Castillo, of Coachella, at the PFE Ice Plant in Colton. In addition, Beto Carrasco would work with family member Manuel Carrasco (second row, second from right), of Coachella, at the Coachella date packinghouse.

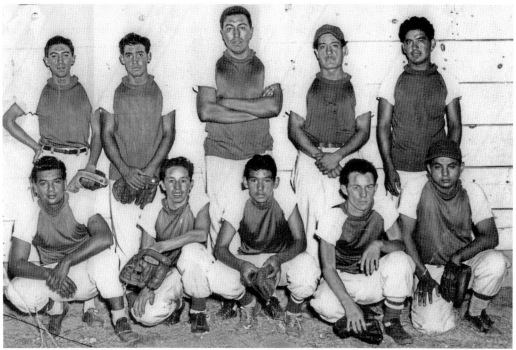

This fast-pitch softball team from Palm Springs was simply known as the "Mexican Colony." The players came from the "section fourteen" barrio located on the Agua Caliente Indian Reservation. The team played in the Palm Springs City League and Riverside County Class A Division. From left to right are (first row) Frank Prieto, Ray Reyes, Oscar Prieto, Don Mendoza, and Art Jurado; (second row) Pete Herrera, Ben Prieto, John Herrera, Sid Canales, and Richard Quiroz. (Courtesy of Victor Reyes.)

This youth team was organized by the Boys Club of Palm Springs and went undefeated from 1945 to 1950. All members pictured here were raised on the Agua Caliente Indian Reservation. The team would often play before the adult baseball games. From left to right are (first row) Charles Smith, Joe Lewis, David Martinez, Victor Reyes, and Tommy Avila; (second row) Alvin Harrison, David Moore, Manuel Montoya, Rufus Lewis, and Jerry Lewis; (third row) Eugene Prieto and James Judd. (Courtesy of Victor Reyes.)

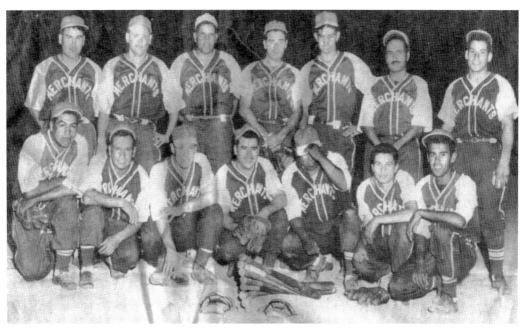

The Coachella Merchants date back to 1929 when the Pioneer Baseball League formed in the Coachella Valley. The 1948 team includes, from left to right, (first row) Callie Rodriguez, Ted Munoz Sr., Vincent Teran Sr., Ray Guerra, Teo Ramirez, Bobby Ramirez, and Tony Rodriguez; (second row) Luie Guerra, Carlos Teran Sr., Charlie Nava, Alex Sicre Sr., Ray Garcia Jr., Mike Castanon Sr., and Simon Rodarte.

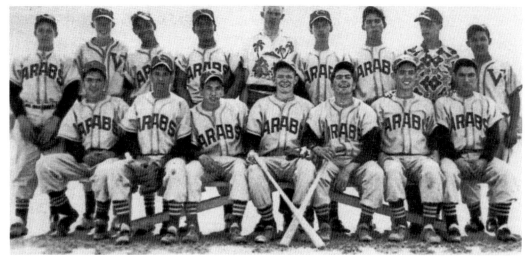

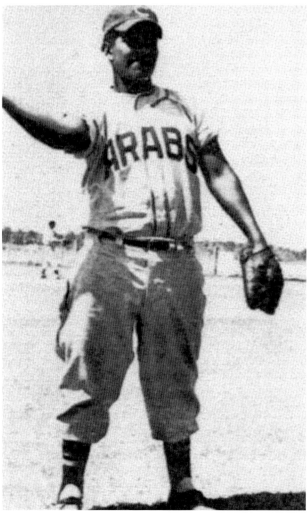

This Coachella Valley High School Arabs team includes, from left to right, (first row) Eddie Moreno, Ted Munoz, Bob Munoz, Don McHargue, Jimmie Bryant, Ben Montoya, and Ignacio Lopez; (second row) Shorty Cunningham, Walt Criner, Ralph Rodriguez, Joe Benitez, Herb Criner, Mike Castanon, Henry Moreno, Jerry Willard, and Dick Montoya. Joe Benitez (at left) eventually became owner of the Fantasy Springs Casino in Palm Springs.

Mexican American Baseball

The Pomona Valley

The Pomona Valley spans across the western end of San Bernardino County and the eastern portion of Los Angeles County. Situated in the foothills of Mount Baldy, this area consists of Ontario, Cucamonga, Pomona, Claremont, Montclair, Upland, San Dimas, La Verne, and Chino. Mexicans settled in the Pomona Valley over a century ago, working railroad yards, packinghouses, citrus fields, and other low-wage jobs. Mexicans were segregated in housing, municipal parks, theaters, restaurants, schools, places of worship, and employment. Despite these racial barriers, the Mexican American leadership of the Pomona Valley established their own mutual-aid societies, fiestas, newspapers, churches, movie theaters, and activities related to the fine arts and sports.

The Pomona Valley is geographically unique in that portions of the region rest within eastern Los Angeles County and lay approximately 30 miles east of downtown Los Angeles. County lines, however, did not culturally, socially, or politically separate the Pomona Valley's Los Angeles County–based communities from the Inland Empire, as their Mexican American baseball teams' games and natural rivals were within San Bernardino and Riverside Counties, especially during the 1920s through the 1940s. During this era, Pomona, Claremont, San Dimas, and La Verne teams regularly played against Chino, Cucamonga, Ontario, Upland, and San Bernardino teams. Several times a year, Pomona Valley teams traveled and played in San Bernardino, Riverside, Palm Springs, Redlands, and the Coachella Valley. In addition, teams like the Cucamonga Browns, Pomona Merchants, Chino Questionettes, Claremont Juveniles, and Cucamonga Mets added to the competitive spirit of Mexican American teams in the Inland Empire. Baseball often nurtured leadership skills for men and women who participated in the game, as they often shifted these talents into political and social arenas to combat discriminatory treatment against Mexican Americans. Candelario "Cande" Mendoza, who played baseball in the Pomona Valley, typified this leadership, as he dedicated his life to Mexican American civil rights. Baseball thus served as a vehicle for civil and social rights for the Mexican American community. Moreover, baseball diamonds served as a crucial space to define gender among men and women in the Pomona Valley.

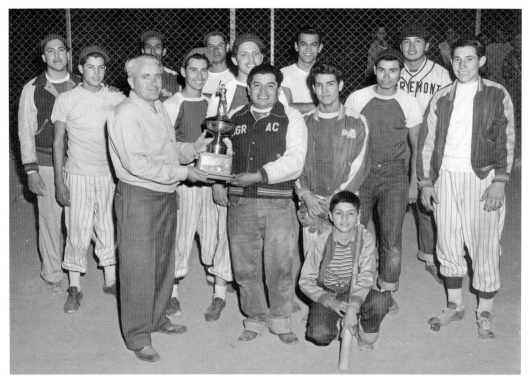

The Claremont Athletic Club won the Claremont Civic Softball League's Bradley Cup Playoffs around 1950. The Athletic Club defeated the Odd Fellows of Claremont High School. The team included two sets of brothers: Ignacio (second row, second from right) and Joe Felix (second row, second from left) and Tony (third row, far left), Paul (second row, third from left), and Freddie Gomez (first row, far right). Another player was David "Nulfo" Villanueva (third row, second from right). (Courtesy of Rudy Felix.)

Al "Poncho" Villanueva, of Ontario, was one of the best pitchers in Inland Empire fast-pitch softball. The Ontario Question Marks were invincible from 1946 through 1950. After marrying Nellie Gutierrez, of Claremont, he started for the Claremont Athletic Club championship teams of the early 1950s. From 1963 through 1979, he continued to pitch for and manage fast-pitch teams from the Pomona Valley, including the Toddy Boys, who won the State Fast-pitch Tournament Championship in 1971. (Courtesy of Al Villanueva.)

Candelario "Cande" J. Mendoza was one of the great ballplayers and civil-rights leaders from the Pomona Valley. He was born in Silao, Guanajuato, Mexico, and arrived in the United States as an infant. Cande played for Pomona High School, Pomona Junior College, and La Verne College. He once went out and received donations so the Mexican American boys would have presentable uniforms in playing against Anglo teams. He served in World War II with Gen. George S. Patton's 3rd Army. After the war, he became an active civil leader in the Pomona Valley and one of the first Mexican American teachers in Southern California. He eventually worked as a counselor, principal, and school board member. A school is named in his honor. He was active in several community groups until his death at the age of 89 in 2008. (Courtesy of Alice Gomez.)

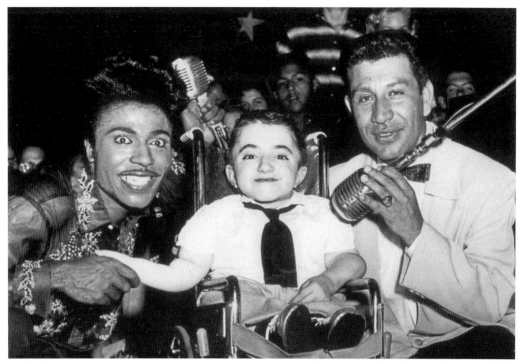

Aside from being an active civil-rights leader and maintaining a career as a public schoolteacher and administrator, Candelario Mendoza (far right) served as an emcee and music consultant at Pomona's Rainbow Gardens dance hall. Mendoza is pictured with Little Richard hosting a rock-and-roll benefit event for disabled children. (Courtesy of Matt Garcia.)

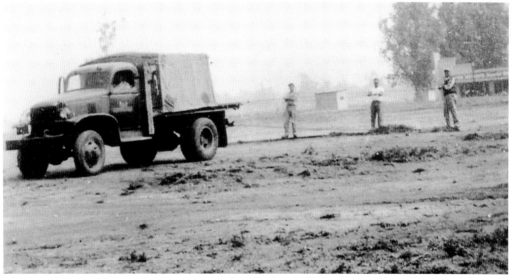

Mexican Americans were often not permitted to play baseball in public parks or school fields because of racial restrictions, thus forcing them to play games in vacant lots around their neighborhoods. This decommissioned Army truck pulled a train rail to drag a rocky field before a game on the corner of Arrow Highway and Hermosa Avenue in Cucamonga around 1947. This field was affectionately named Junkee (Yonke) Stadium by Fortino Mendoza. (Courtesy of Al Vasquez.)

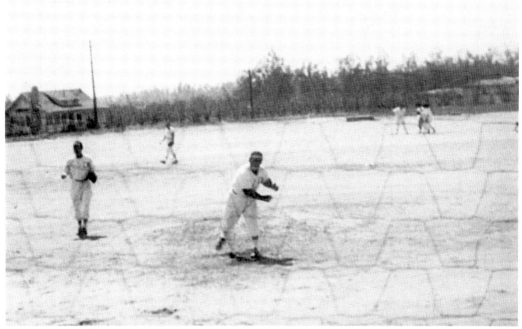

This is Junkee (Yonke) Stadium after it has been smoothed out and prepared for a game. Most of the fields in the Inland Empire were sandlots often found on the outskirts of town near railroad yards, factories, citrus fields, canneries, foundries, steel mills, and cow pastures. The fields generally had homemade scoreboards, a public-address box, bleachers, food vendors, parking spaces, team trainers, bases, and benches for the teams. The players had their uniforms, their lunches, windbreakers, and bags to carry their bats, gloves, and cleats. The teams and players took great pride in showcasing their fields and uniforms. (Courtesy of Al Vasquez.)

This c. 1949 photograph was taken on a Sunday road trip from Cucamonga to the Soboba Indian Reservation in Hemet. Taking Route 60 through Riverside in a "chopped up" Model A, the trip took about two hours. The driver is team manager Alcario Acuna. Alfonso "Poncho" Ledesma snapped this image from the back of a flatbed pickup truck that was used to haul players and equipment. Sometimes, these vehicles were also used for quick getaways from hostile fans if they beat their home teams. (Courtesy of Al Vazquez.)

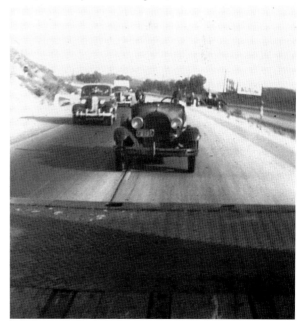

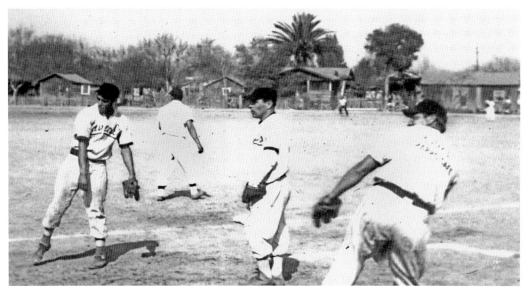

This baseball field was in the Mexican American community in Claremont. The fans enjoyed watching the Juveniles players practice before games, especially (from left to right) Maury Encinas, Leo Garcia, and Tony Grijalva. While the catchers would warm-up their pitchers, and the umpires would go over the ground rules with both managers, the field was being prepared. Sundays were special in the Mexican American community: church in the morning and baseball in the afternoon. (Courtesy of Angie Torrez Pippins.)

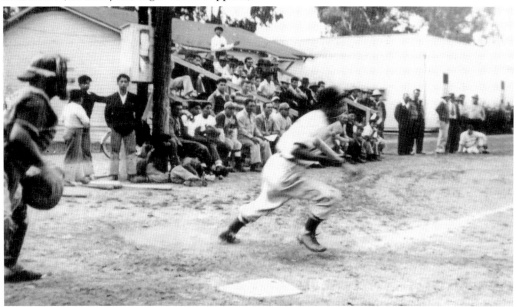

Fans would sit in bleachers built by carpenters and construction workers. At some fields, the bleachers were reserved for diehard fans, known fondly as ticket holders. Others sat in the outfield grass or on the hoods of their cars. At sunset, cars encircled the field and used their headlights as illumination to finish the last few innings of a game. A collection was taken during the game for the visiting team to purchase sandwiches and gas for their return home. (Courtesy of Angie Torrez Pippins.)

Games in the Pomona Valley were hard fought and competitive, with players giving their best effort at all times. They ran hard on every play, as indicated by the photograph at right showing Luis Vasquez, of Cucamonga, running for home plate. Community pride was at stake, and each team desperately wanted to win. Despite the heated nature of these games, there were few arguments or fights among players or between the players and umpires. Some teams had trainers who attended to injuries, especially the common ankle sprain. In Spanish, the trainer was referred to as *el sobador*, and remedies often involved liniment or volcanic oil and a rubdown. Quick healing allowed one to preserve his spot in the lineup and also ensured that he could get back to work on Monday. Below, sitting on the bench are, from left to right, Delfino Anguiano, Chevo Hernandez, and Tony Lujan. (Courtesy of Al Vasquez.)

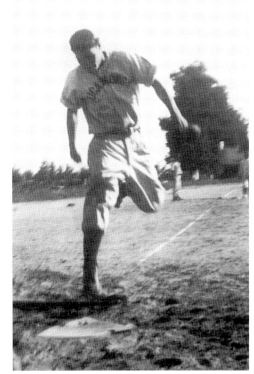

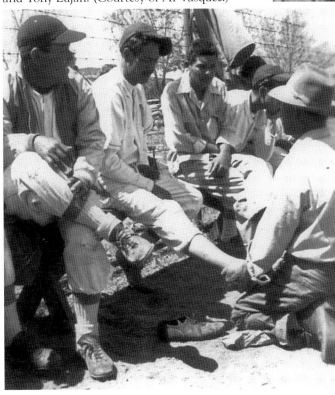

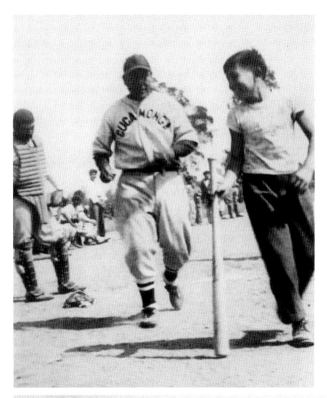

Sons often served as batboys and sat with their fathers on the bench, which inspired a love for baseball at an early age. Many athletes in the Pomona Valley had fathers, uncles, and older brothers who played before them and served as powerful role models for these youngsters. Delfino Anguiano (left) scores while batboy Louis Ledesma cheerfully greets him at home plate. Many fathers started teams to keep their sons, nephews, and younger relatives out of trouble at school and in the streets. Joe "Chino" Torrez (below) holds his infant son. Later on, many of these second- and third-generation players became mangers, directors of parks, umpires, and scouts. Baseball has been passed down from generation to generation since the early 1920s in the Pomona region. (Courtesy of Al Vasquez.)

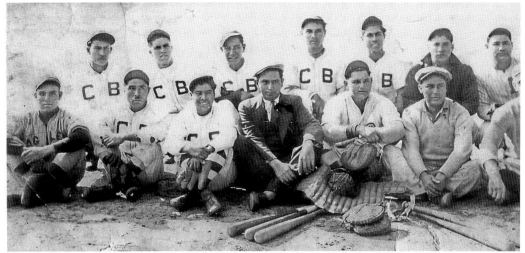

The Cucamonga Browns were founded by Capt. Jack Brown Sr., the sheriff of San Bernardino County in the 1930s, to help young boys stay out of trouble with the law. The manager was Esteban Montes (first row, second from right). Among the outstanding players were Chilo Martinez (second row, second from right), who was scouted by the Chicago White Sox, and brothers Pete (front row, second from left) and Kiko Torrez (second row, third from right). Jack Brown Jr. is the CEO for Stater Bros. Markets. (Courtesy of Al Vasquez.)

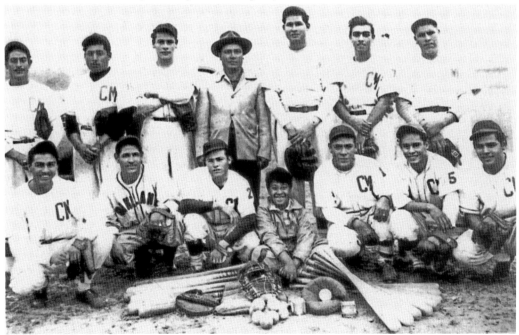

This image shows the Cucamonga Merchants of 1946. Nearly every Mexican American community had a Merchants team. The team got its name because the local merchants sponsored the team with uniforms, baseball equipment, gas for road games, and other necessities. Sometimes, however, the local merchants provided almost no support for the team. The team manager was Esteban Montez (second row, center). His son Esteban is the batboy. A number of teams had Mexican braceros playing for them. (Courtesy of Al Vasquez).

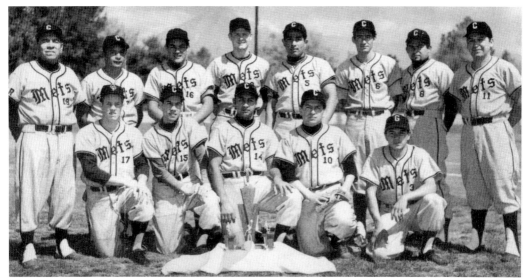

The Cucamonga Mets were formed in the late 1950s and continued playing until the 1980s. Their home field was in south Cucamonga in an area known as El Depot. The Mets won 11 consecutive Sunset League championships playing against teams from Upland, Indio, Palm Springs, San Bernardino, and Riverside. This team featured brothers Sonny (second row, third from right), Fernie (first row, second from left), and Agustine Vasquez (first row, third from left), as well as their cousin Tino Torrez (second row, third from right). (Courtesy of Al Vasquez.)

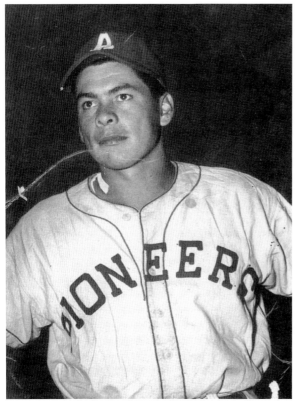

Leo "Slam" Garcia was a remarkable athlete in the Pomona Valley, playing baseball at Claremont High School, on Sundays with Los Juveniles, and professionally with the Ontario Orioles and the Austin (Texas) Pioneers of the Class-B Big State League. He once played an exhibition game against the New York Yankees, which featured Joe DiMaggio, Yogi Berra, and Phil Rizzuto in their lineup. Garcia, who lives in Hawaii at the age of 90, served in World War II and received three Purple Hearts and the Bronze Star.

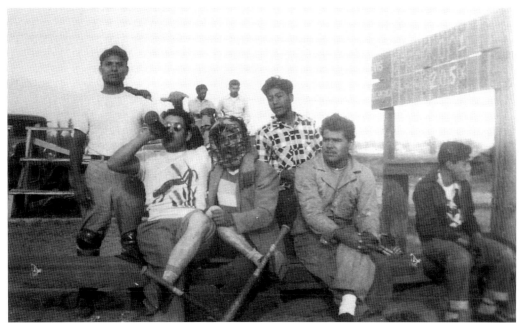

Baseball provided a space to reinforce notions of masculinity. The home team took a collection for beer and snacks, sometimes drinking beer after the game and joking around, like above with Cucamonga players Phillip Lujan (left, with the bottle) and Tito Mendoza (to the right of the Mexican bracero with the catcher's mask on). The little boys are Nacho Acuna (sitting) and Perfecto Parrilla (standing). The photograph below shows Ontario players from the Question Marks team retreating to a wooded area known as Marrano Beach for beers and a friendly game of dice. Baseball and the ceremonial beer drinking after games were social outlets for players to release their stress from an oppressive society. Baseball provided solidarity, as players bonded with other players from their community and other Mexican American communities. (Above, courtesy of Al Vasquez; below, courtesy of Al Villanueva.)

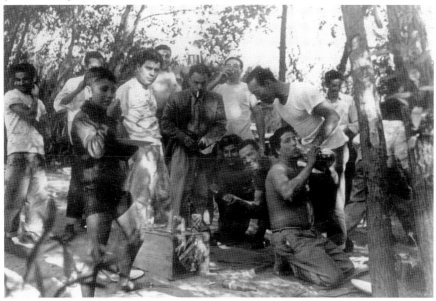

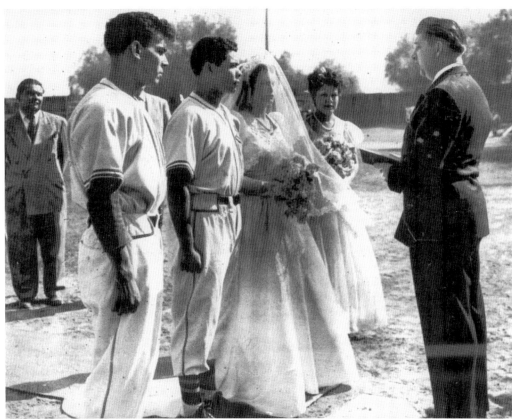

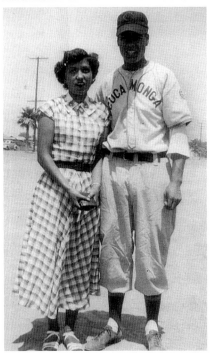

In addition to baseball's role as a social linkage that later expanded into political networks, marriages between players and their girlfriends expanded familial networks. As players traveled around the Inland Empire and throughout California, they met and married women from other communities. Above, Leo Garcia marries Dorothy Riggins at John Galvin Park in Cucamonga around 1950. Since players' neighborhoods were generally related by blood in their own communities, these out-of-town marriage vows united almost everyone together in the Pomona Valley. Al and Carmen Montes Vasquez, seen at left, met through baseball and other social activities. Carmen's father, Esteban Montes, was the manager of the Cucamonga Merchants. Al and Carmen had three sons, Juan, Steve, and Anthony, who have continued the rich tradition of baseball.

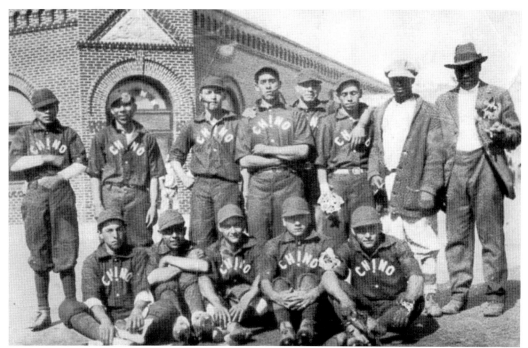

This 1919 Mexican American team in Chino was managed by a former player (second row, far right) from the Negro Leagues, who was one of the few African Americans to live in the Pomona Valley. The photograph's donor heard stories passed down from her grandfather Eliseo Martinez that the African American manager volunteered his baseball knowledge to the local Mexican American team. The younger African American man (second row, second from right) may have been the manager's son. (Courtesy of Olivia Garcia.)

Candelario "Cande" Mendoza was one of the great ballplayers and civil-rights leaders in the Pomona Valley. Mendoza even played against Jackie Robinson, the first African American man to play major-league baseball in the 20th century. In this photograph, Mendoza is practicing his swing at the family home on Twelfth Street.

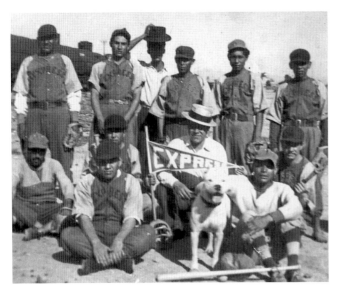

This Mexican American team played in Cucamonga around 1936. Called the Express, it appears to be a railroad team with a few players wearing railroad caps and clothing. Most of the railroads in the Inland Empire sponsored baseball teams comprised largely of Mexican American players. Successful teams were viewed by management not only as a source of company pride and a morale booster, but also as a tool to distract employees from harsh working conditions and low wages and to discourage players from union involvement.

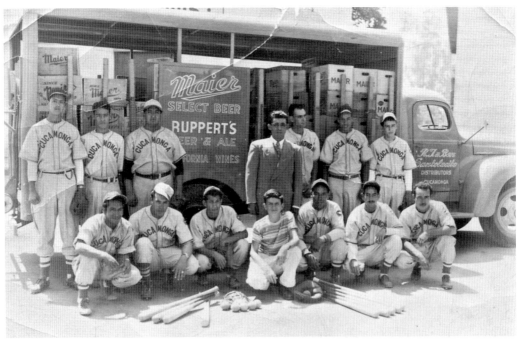

While the Maier Beer Company–sponsored baseball team represented Cucamonga, its roster included players from several communities: from Ontario, Eddie Jimenez (second row, far left); from Fontana, Ray Aparicio (second row, third from left); from Mexico, Charro Martinez (first row, far left); and from La Verne, Poke Guerrero (first row, third from left). Brothers Al (second row, second from right) and Luis Vasquez (second row, second from left) were from the Pomona Valley. The young scorekeeper is Alfonso "Poncho" Ledesma (first row, center). (Courtesy of Al Vasquez.)

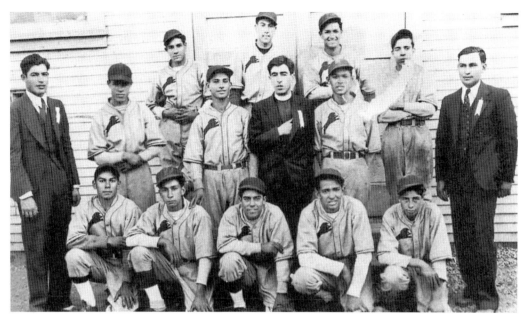

The Catholic Church played a major role in promoting sports in the Inland Empire by sponsoring baseball, football, and basketball teams. Sports were seen as a means for a clean and religious life. The priests, who served as coaches, hoped that these boys and young men would attend church services and even participate as altar boys, servers, and ushers. This photograph was taken in the city of La Verne. The teams were generally called Guadalupanas and played in the Catholic Youth Organization and Mission Leagues, among others. (Courtesy of La Verne City Hall.)

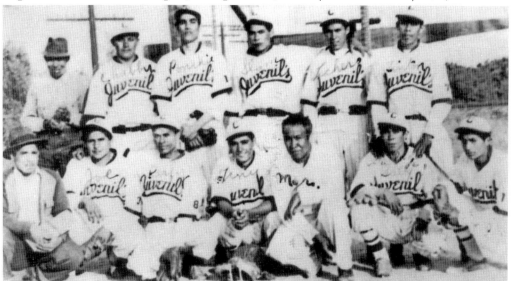

Another form of baseball in nearly every Mexican American community was the juvenile teams, or in Spanish the name Juveniles. These players ranged in age from about 16 to 21 years of age and were often scouted by company, semiprofessional, and adult teams. The Juveniles were much like farm teams with players evaluated and later recruited to join an adult team or replace an injured player. Joe "Chino" Torrez (first row, third from right) and Leo "Slam" Garcia (second row, third from right) were two of the outstanding players. (Courtesy of Angie Torrez Pippins.)

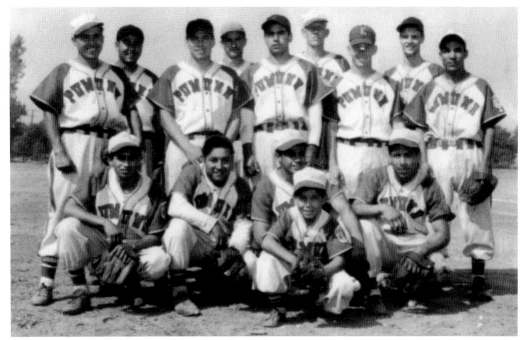

Brothers and their relatives often played together on many Mexican American teams in the Pomona Valley. The 1953 Pomona Merchants, for example, featured three Guevara brothers and a brother-in-law. The three brothers are Leo (second row, far left), Al (second row, far right), and Benny (batboy). Their brother-in-law is Joe Garcia (first row, second from left). The Merchants played teams from Colton (including the Mercuries), Corona, Chino, San Bernardino, and Los Angeles. (Courtesy of Richard Garcia.)

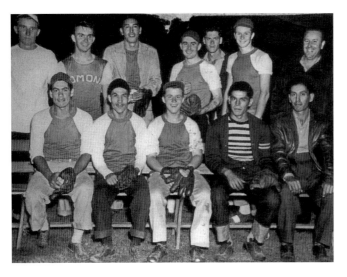

While there were hundreds of teams in the Pomona Valley from the 1930s through the 1950s, only a handful are still fondly remembered. One of the most unique was the 1946 Pomona Granger team, which had outstanding players, such as George Encinas (second row, third from left), Leo "Slam" Garcia (first row, far left), Pete Baltierra (first row, far right), Alfonso "Ponchi" Guevera (first row, second from left), and Maury Encinas (first row, second from right). (Courtesy of Angie Torrez Pippins.)

Transnational and Military Baseball

Mexican Americans Playing Abroad

The baseball experience of Mexican Americans extends beyond the borders of the United States. Mexican Americans have played for teams in Mexico and Canada and have traveled extensively around the globe on United States military teams, visiting dozens of countries in South America, the Caribbean, Europe, and Asia. These players were excellent ambassadors, showcasing their best baseball skills while publicly demonstrating the best cultural values taught to them by their families.

There were three categories of Mexican Americans who played baseball in Mexico. First were those who played year-round in both the United States and Mexico, often six months in each country. Another group, born and raised in the United States, played their entire careers in Mexico. Even though these players were sought by local teams and professional leagues in the United States, they preferred Mexican baseball for many reasons: higher salaries, less traveling, bigger stadiums, larger crowds, and extensive television and radio coverage. Another reason that Mexican Americans played in Mexico was to escape discrimination in American professional baseball. The final group of players was actually born and raised in Mexico and established themselves as Mexican stars. Many decided to come to the United States to test their baseball skills, and a handful were signed by major-league clubs to play on their farm teams. Some became United States citizens and gradually assimilated into the Mexican American culture.

This chapter also highlights Mexican Americans who played baseball while serving in the United States military. For Mexican American troops during World War II and the Korean War, baseball brought temporary relief from the horrors of combat. For many of these players, their travels throughout the world changed their cultural outlook and eventually their lives. Some of these veterans returned home to play baseball again, proudly wearing their military belts to demonstrate that they had defended their country and now wanted to be treated as first-class citizens. Many civil-rights groups, such as the GI Forum, League of United Latin American Citizens, and Mexican American Legion Posts, sponsored baseball and softball teams after the war to promote civil and political rights.

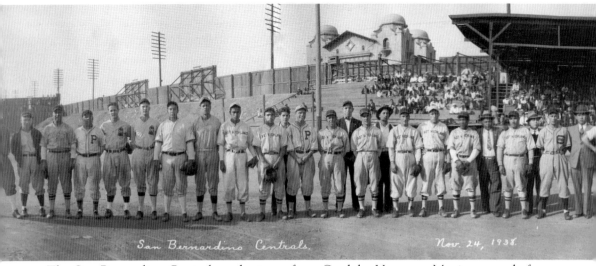

The San Bernardino Centrals and a team from Cordoba Veracruz, Mexico, pose before a transnational baseball match at the Santa Fe Railroad depot on November 24, 1938. The Centrals featured players from San Bernardino, East Highland, and Colton and often played visiting teams

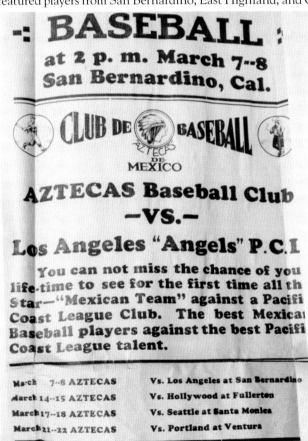

This poster announces a game between the Aztecas Baseball Club of Mexico and the Los Angeles Angels of the Pacific Coast League (PCL) in San Bernardino. During the 1920s and 1930s, several Mexican clubs would barnstorm through the Southwest and Midwest playing Mexican American, Negro, semi-professional, and professional teams. In addition to the Angels, the Aztecas had games against other PCL teams, including the Hollywood Stars, Seattle Rainiers, and Portland Beavers. (Courtesy of the Orozco Baseball Collection.)

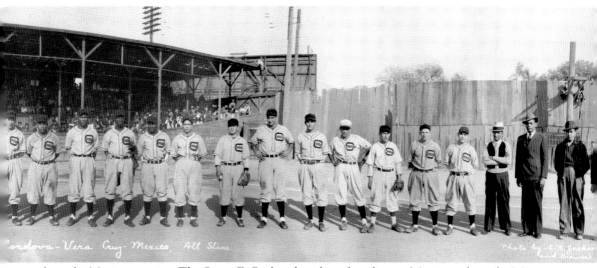

from the Mexican nation. The Santa Fe Railroad yard employed many Mexicans from the Mount Vernon barrio and often hosted baseball games within the company's facilities.

Alex Rubalcava played in the Inland Empire for many years as a pitcher and third baseman for Manny's of San Bernardino, which traveled to Tijuana and Mexicali to compete against Mexican teams. Likewise, teams from Mexicali and Tijuana would travel to San Bernardino to play against Manny's at Old Gateway Park on Fifth Street in the Mount Vernon Mexican American community. These spirited games brought together family members who lived on both sides of the border. (Courtesy of Alex Rubalcava.)

One of the greatest Mexican American players during the 1920s and 1930s was Robert "Lakes" Lagunas. The English word for *lagunas* is "lakes." He played for several years in Mexico, mainly because of the harsh discrimination he faced playing in Texas and New Mexico. There were a handful of players, such as Lagunas, who distinguished themselves on both sides of the border. Mexican Americans who played in Mexico often recruited family and friends to play there as well. (Courtesy of Bob Lagunas.)

An Inland Empire baseball and softball legend Jim "Chayo" Rodríguez (second row, far left) played for the Colton Mercuries, who won a doubleheader against an all-star team in Tijuana, Mexico. Since 1942, Rodríguez has played for and managed dozens of baseball and softball teams at the amateur and semi-professional levels. Now in his 80s, he still serves as an assistant coach for a high school girls' softball team. (Courtesy of Jim "Chayo" Rodríguez.)

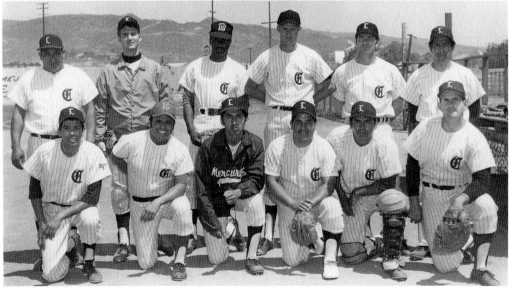

Born in Guanajuato, Mexico, in 1895, Concepción Juárez Padilla came to the United States in 1900. She married Manuel Padilla, an Arizona native who was an outstanding catcher at Tucson High School. His baseball skills earned him jobs during the Great Depression, including playing for the Southern Pacific Railroad team. Like many couples during this era, their marriage was a bi-national one with families on both sides of the border playing baseball. Their son Al Padilla became an outstanding baseball and football player and coach in East Los Angeles. (Courtesy of Al Padilla.)

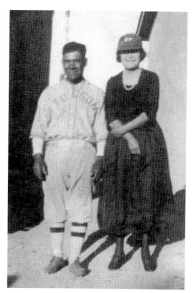

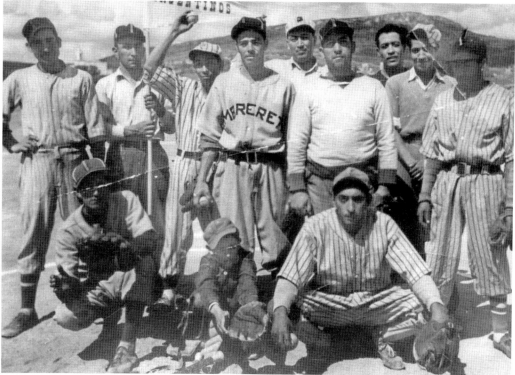

The batboy in this 1938 photograph taken in Sombrete, Zacatecas, Mexico, is Los Angeles–born Andrés Longoria Jr., whose family was repatriated to Mexico when he was an infant. Andrés later moved back to Los Angeles as a teenager and lived in the neighborhood of Palo Verde. When he returned home after serving in the Korean War, the homes in his neighborhood were being condemned to eventually build Dodger Stadium. Jaime and Hector, two of his sons, played baseball at Loyola High School and in the Mexican American leagues in Los Angeles. (Courtesy of Jaime Longoria.)

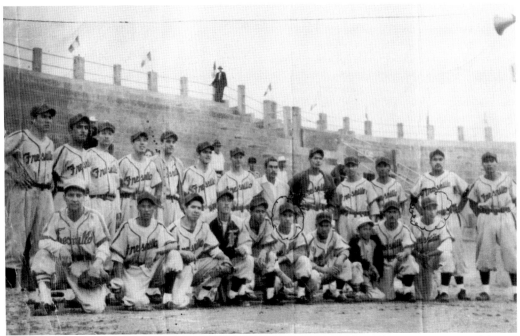

José Rivera (first row, kneeling, far right) pitched for the 1946 Fresnillo team, sponsored by an electric company in Chihuahua, Mexico. He was scouted by the Pittsburgh Pirates and given a tryout in Los Angeles in 1952. José later played for several Los Angeles teams. Ramiro Cuevas (first row, fifth from right), another pitcher, reportedly threw the first perfect game in Mexican professional baseball history and eventually played semi-professional ball in Los Angeles. (Courtesy of José Rivera.)

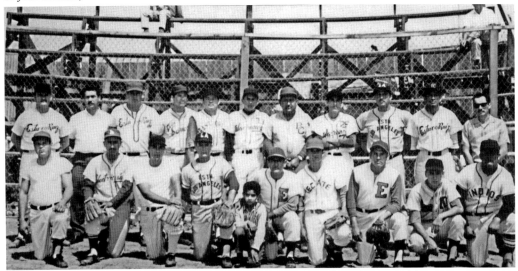

One of the best players to come out of Mexico and later play ball in the United States was Nemorio "Willie" Alvarez-Tostado. Born in 1937 in Tijuana, Alvarez was considered too skinny to play baseball in his hometown but later developed into one of Mexico's top amateur pitchers. In this photograph of the 1965 state championship team of Mexico, Alvarez is in the second row, fourth from right. (Courtesy of Willie Alvarez.)

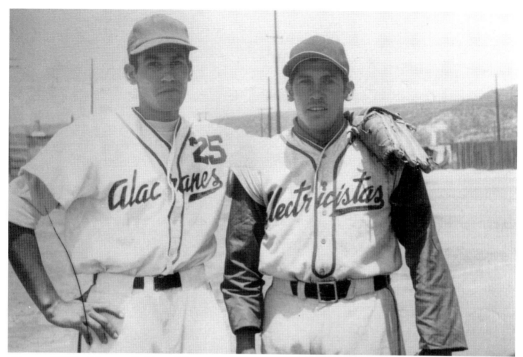

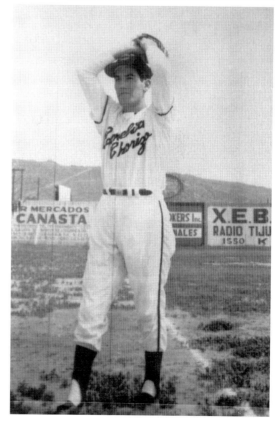

Above, Willie Alvarez (left) and Luis García (right) were outstanding players in Mexico. In 1957, Alvarez was chosen to represent Baja California Norte in the national championship in Matamoros, Tamaulipas, Mexico. In 1966, in Baja, California, he won his third state title by outdueling Gabby de la Torre, another great pitcher, for a 2-1 victory. Alvarez decided to bring his competitive spirit and baseball skills to the United States in 1959. Manuel "Shorty" Pérez invited him to join the Carmelita Chorizeros, and he would play many years for this legendary East Los Angeles semi-professional team, winning numerous city championships in the process. Shorty even became godfather to Willie's son Guillermo. With Carmelita, Willie played against teams in Tijuana and Mexicali—the bi-national cycle was now complete. (Courtesy of Willie Alvarez.)

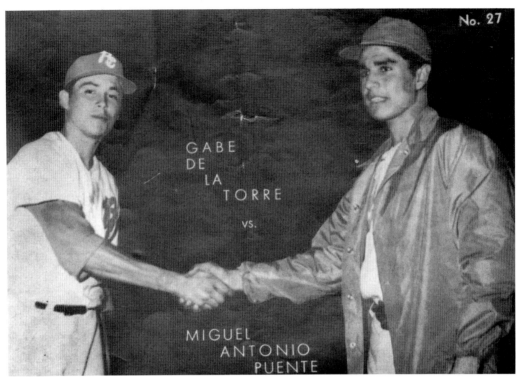

Raised playing baseball in San Jose, California, Gabriel "Gabby" de la Torre (left) moved to Mexicali, Mexico, in 1964, where he pitched for the Instituto de la Joventud Mexicana (INJM). As a starting pitcher for Mexicali in the 1965 Mexican National Tournament in Tijuana, Gabby struck out 40 batters against Chihuahua, winning the game 1-0 in 16 innings. He is shaking hands with Miguel Antonio Puente, who also went the distance of 16 innings in a losing cause. The newspaper articles reported his 40 strikeouts in one game as a possible world record. In 1966, Gabby was the starting pitcher for the Mexican national team in the Pan American Games in Puerto Rico. (Courtesy of Gabriel de la Torre.)

Ernie de la Torre, brother of Gabriel, was a high school and community college pitcher in San Jose, California, in the early 1970s and signed a professional contract to play in Mexico in 1977. He pitched for the Yaquis de Obregón, champions of the Pacific Coast League in 1979. While playing for Los Dorados de Chihuahua in 1982, the players walked out for better benefits and salaries. De la Torre was blacklisted for his strike activities, thus ending his baseball career. (Courtesy of Ernie de la Torre.)

A native of East Los Angeles, Armando Pérez (first row, third from left) played for the Puebla team in Mexico in the mid-1950s. He recalls that his Spanish was limited, making it awkward to communicate with other players and fans, but it eventually improved as a result of conducting media interviews in Spanish. Besides developing their baseball skills, Mexican Americans who played in Mexico learned about the language, culture, and history of their parents' homeland. (Courtesy of Armando Pérez.)

Tom Pérez Jr. (far left) was player-manager for Jean's Falcons in a 1964 game in Tijuana. Most of the Falcons formerly played at Roosevelt High School. Pérez, on the other hand, had attended Garfield High School. Many Mexican American clubs, such as the Falcons, who were based in East Los Angeles, had agreements with teams from Mexico to play home and away games with each other. (Courtesy of Tom Pérez Jr.)

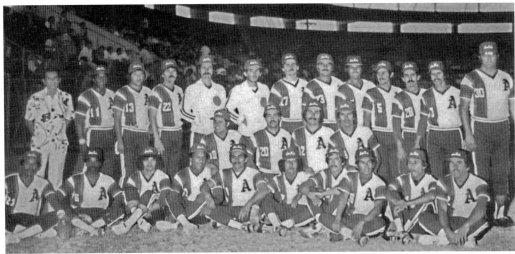

Born in the Boyle Heights section of East Los Angeles, Gilbert Gámez Jr. made a major contribution to the international development of baseball in a career that took him to Canada, Mexico, Korea, Haiti, the Dominican Republic, and Puerto Rico. After a successful career playing baseball and umpiring in the United States, Gilbert devoted several years to scouting, coaching, and managing teams around the globe. Gámez (second row, far right) managed Los Algodoneros de San Luis R.C. Mexican team in 1979. (Courtesy of Gil Gámez Jr.)

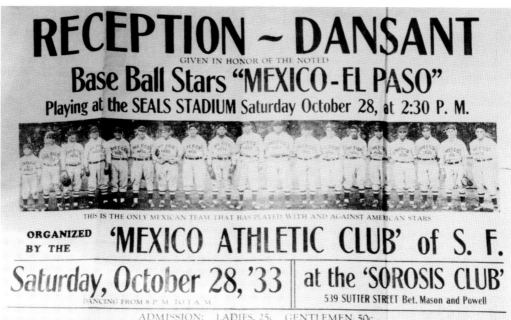

During the 1920s and 1930s, there were several organizations that sponsored baseball games between Mexican and Mexican American teams. This poster announces a 1933 game at Seals Stadium sponsored by the Mexican Athletic Club of San Francisco. Pitcher Dave Salazar (fifth from left) is the grandfather of Darrell Evans, who played for the 1984 world champion Detroit Tigers. (Courtesy of the Orozco Baseball Collection.)

The city of Guadalupe near Santa Maria has historically been a diversified community with Japanese, Mexican, Portuguese, and Filipino farmworkers. Baseball enthusiast Setsuo Aratani sponsored a team from the community in 1928 to compete in Japan in a series of goodwill games. On the roster were two Mexican Americans: brothers Frank (fifth row, far left) and Tony Montez (fifth row, far right). The Guadalupe team won 27 of 30 games against outstanding Japanese teams. (Courtesy of the Guadalupe Cultural and Arts Center.)

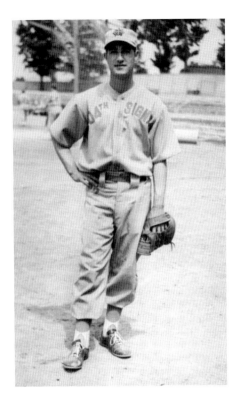

Carlos Uribe was assigned to the 304th Signal Corps Battalion in South Korea in December 1952. The following June, Uribe's unit organized a team in the Seoul City Command League. All six teams in the league played at Seoul City Stadium. A pitcher and outfielder, Uribe recalled that he was the only Mexican American on an all-Anglo team. He played for one season before returning home in 1954. (Courtesy of Carlos Uribe.)

Born in Corona, California, in 1932, Luis Uribe was the catcher for his military team in Orleans, France. His three brothers—Alfredo, José, and Carlos—were talented players for the Corona Athletics, a powerhouse baseball team in the Inland Empire during the 1930s through the 1950s. Besides playing ball, they worked together as citrus pickers. All four brothers were scouted and eventually signed by major-league baseball organizations. (Courtesy of Carlos Uribe.)

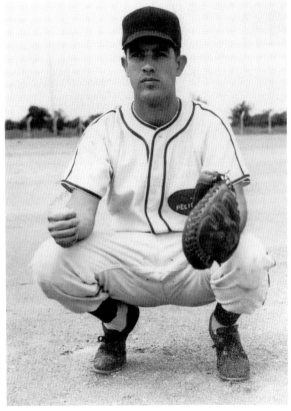

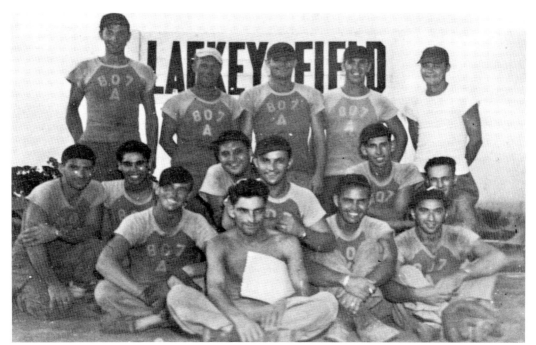

Tommie Encinas (second row, second from left) pitched in Okinawa, Japan, during World War II, competing against over 100 military teams. His battalion team reached the Eastern Theater Tournament, finishing in second place only because a teammate had missed home plate after hitting a home run. Trained as a medic, Tommie was called back to tend to casualties, especially among the Marines. He also served on the island of Guam. (Courtesy of the Tommie Encinas Baseball Collection.)

In this historic photograph of Lackey Field, it is believed that the pitcher on the mound is Tommie Encinas. Despite wartime conditions, many people attended the military games. Several Mexican Americans observed that baseball was a way to connect with the normalcy of life at home and to channel their energies in a positive way to relieve the stress of combat. (Courtesy of the Tommie Encinas Baseball Collection.)

Eugene Sam Sandoval served in the Korean conflict from July 16, 1953, to May 26, 1955, making the rank of technical sergeant. He played military baseball in Korea and Japan and was an outstanding second baseman. Sammy, as he was known to family and friends, played ball all of his life, including youth, high school, community, military, and senior leagues. He died at the age of 77 in 2011 in his hometown of Riverbank. (Courtesy of Olivia Sandoval.)

Born in Chino in 1924, Jess Briones joined the US Army in 1944 and played for several teams in the military. Stationed at Fort Bragg, North Carolina, Briones, in the center of this photograph with four of his teammates, played shortstop and outfield. He was an outstanding athlete with exceptional speed on the base paths and great fielding skills. Several of his coaches marveled at his accurate throwing arm and believed he could go high in organized ball after he left the service. (Courtesy of the Briones family.)

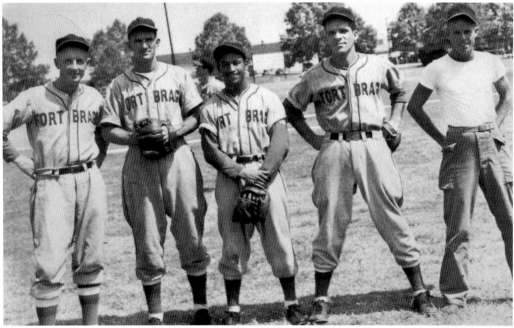

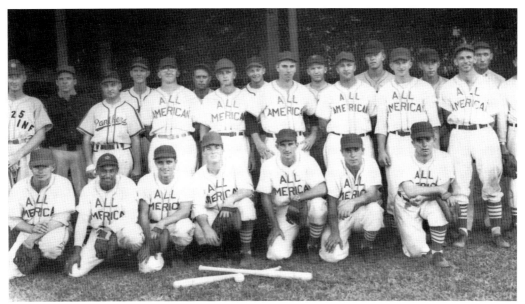

Jess Briones (first row, second from left) played baseball with this All-American team against other military teams, often traveling far distances to play on opponents' diamonds. Despite the long plane rides, humidity, and subpar living quarters, many Mexican American servicemen recalled that they truly enjoyed the competition, traveling with their teammates, meeting new people, and visiting places that they had never been to. They also appreciated the recognition by their fellow soldiers regarding their outstanding baseball skills. (Courtesy of the Briones family.)

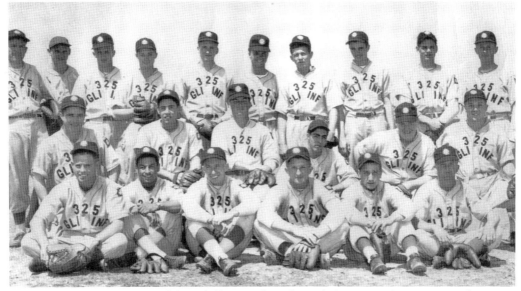

Jess Briones (first row, second from left) was often the only Mexican American on the team. Mexican Americans on military service teams experienced a wide range of reactions from their teammates. While some felt isolated from fellow players because of racial prejudice, others were treated fairly by most of their teammates. A few Mexican Americans believed their presence helped erase racial tensions, as some Anglo players reluctantly accepted their baseball talents. (Courtesy of the Briones family.)

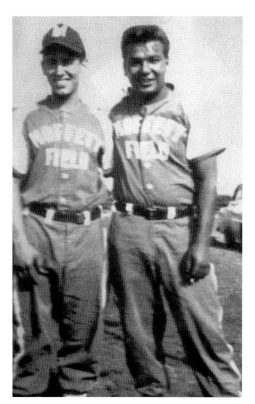

Born in Banning, California, and raised in Palm Springs, Frank Prieto (right) joined the Navy and was stationed at Moffett Field in Sunnyvale, California. He pitched for his service team and became close friends with Ray Salazar (left), of New Mexico, who managed the team. They played together in Hawaii and other locations in the Pacific. Despite living in different states, their incredible friendship endured until 2011 when Prieto passed away. (Courtesy of the Ray Prieto family.)

Born in Dewey, Oklahoma, in 1920, Ray Delgadillo (left) played for the Corona Athletics between the 1930s and 1950s. At the beginning of World War II, he played for the Mexican team Aguas Caliente in Guadalajara. Delgadillo was drafted into the Army and was stationed in Australia, New Guinea, and the Philippines. Delgadillo and other servicemen created teams as a form of leisure in Australia. His teammates decided to call themselves the Dodgers after the Brooklyn Dodgers. (Courtesy of Ray Delgadillo.)

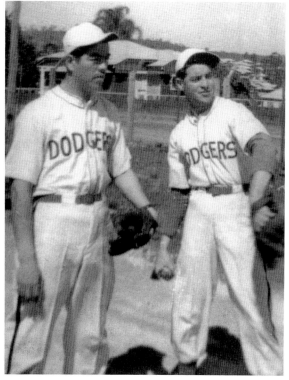

Charlie Sierra entered the US Air Force in January 1949 and completed his basic training at Lackland Air Force Base in Texas, followed by courses in hydraulics and instruments at Chanute Air Force Base in Illinois. He was sent to Travis Air Force Base, where he was assigned to the 9th Field Maintenance Squadron, 9th Bomb Wing. He spent time overseas in Hawaii, Guam, Wake Inland, the Kwajalein Inlands, and Japan. He played on several military teams. (Courtesy of Charlie Sierra.)

In 1949, Charlie Sierra played first base for the Travis Air Force Base team. Travis is one of the largest bases in California. The team won the California Air Force championship and traveled to Hawaii to beat the Hickam Air Base team for the Pacific Baseball championship. Sierra (left) was voted the outstanding player of the series. He recalls that nearly all of his teammates refused to shake his hand for winning this award because of racial prejudice. (Courtesy of Charlie Sierra.)

Ernie Benzor (at left) served in the military during World War II from 1944 to 1946. He later served in the Korean War and eventually made sergeant first class. In 1948, Benzor played second base and shortstop for the Casa Blanca Aces, a team comprised mainly of returning World War II veterans. Like many of his teammates in this photograph, Benzor (second row, second from right) is wearing his military belt. The players wore their military belts with their baseball uniforms to make a political statement that they were veterans and wanted to be treated as first-class citizens. Leo Baca (second row, far right), the manager of the Aces, was the sixth-grade teacher at Casa Blanca Grammar School, which was segregated for many years. Benzor went on to manage the Vagabonds team that won the championship in the Rubidoux League in 1957 and placed second in the Riverside Division in 1956. (Courtesy of Ernie Benzor Jr.)

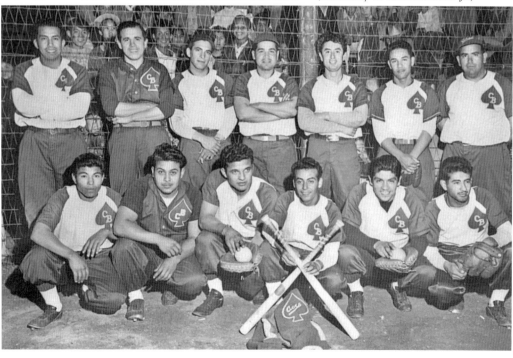

Professional Baseball

American Dreams for Mexican Americans

Like many young baseball players, Mexican American youth dreamed about playing in the big leagues. While there were a handful who were fortunate enough to sign professional baseball contracts and a few who eventually played in the majors, the harsh reality was that there were racial barriers that prevented many Mexican Americans from realizing their goal of playing for teams like the Yankees, Dodgers, Red Sox, Cardinals, and Cubs. A number of Mexican American players recalled that there were almost no scouts in their communities and even fewer tryouts at local high school and college fields. Some even traveled far distances to take part in tryouts only to be turned away because major-league teams were not giving contracts to Mexican American players.

Despite racial discrimination, there were a few enlightened scouts who signed Mexican American players because of their outstanding baseball skills. For those who signed contracts, it was a major cultural shock to be assigned to minor-league teams in the Deep South, where Jim Crow laws were violently enforced. Mexican American players often found themselves confused when these "norms" were applied to them as well. Mexican American ballplayers were often the only persons of color on teams and faced racial tension because of the fact that they were competing against whites to make major-league rosters.

Several Mexican American players recall that the minor-league coaching staffs spent considerably more time working with white players than with Mexican Americans and African Americans. Even if Mexican Americans had better hitting, running, and fielding skills, it made little difference in the face of institutionalized racism. Despite all of these obstacles, some Mexican Americans did make it to the major leagues, albeit usually for far less money than their Anglo colleagues.

For many of the Mexican American ballplayers who did not make it to the major leagues, they returned home, played locally, and coached Little League through high school and college. A special few went to Mexico to coach and manage, and others became umpires at the college and minor-league levels. These former players are now being publicly saluted for their pioneering spirit that helped break down racial barriers so that generations of Mexican Americans who followed them could play in the big leagues.

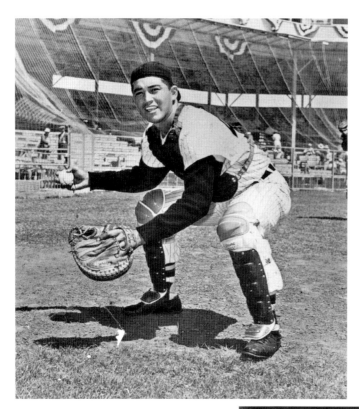

Upon graduation from Colton High School in 1956, Camilo Carreon signed with the Chicago White Sox organization. Playing for the Indianapolis Indians of the Triple-A American Association in 1959, Carreon hit .311 and earned Rookie of the Year honors. In nine minor-league seasons, Carreon played in 694 games with career totals of 29 home runs, 99 doubles, 17 triples, 189 runs batted in, and a .282 batting average. (Courtesy of Pete Carrasco.)

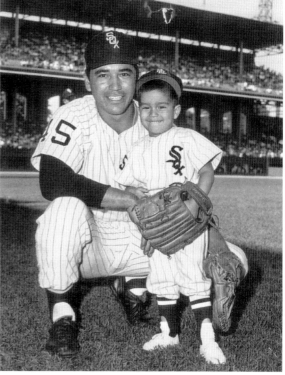

Called up to the Chicago White Sox in 1959, Camilo Carreon backed up the great catcher Sherman Lollar. After six years with the Sox, he played briefly with the Cleveland Indians and Baltimore Orioles. In eight major-league seasons, Carreon played in 354 games with career totals of 11 home runs, 43 doubles, four triples, 114 runs batted in, and a .264 batting average. In this photograph, he is seen with his son Mark, who also played in the majors. (Courtesy of Pete Carrasco.)

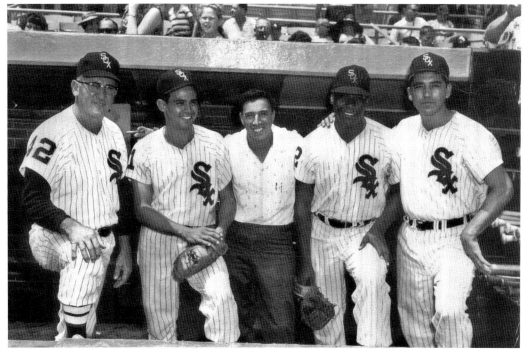

Camilo Carreon (right), Luis Aparicio (second from left), Juan Pizarro (second from right), and manager of the Chicago White Sox Al Lopez (far left) are seen in this photograph. The city of Chicago has one of the highest populations of Mexican Americans in the United States. The White Sox was one of the first teams to stock its roster with Latino players, and Mexican Americans came out in numbers to watch their favorite heroes. (Courtesy of Pete Carrasco.)

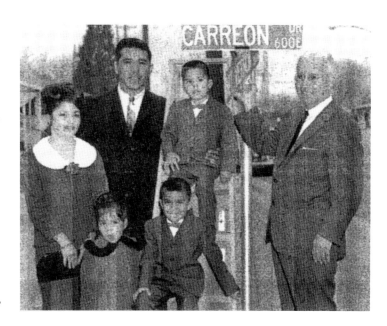

Carreon Drive in the city of Colton was dedicated on July 10, 1966, in honor of local baseball hero Camilo Carreon. Carreon proudly stands with his family as they dedicate the street in his honor. While with the Chicago White Sox, Carreon was also presented with the Colton Citizens' Committee Award before a game at Chavez Ravine. Part of the trophy read, "To Camilo Carreon, Latin American Ambassador of Goodwill."

MEXICAN AMERICAN BASEBALL IN THE INLAND EMPIRE

Born in 1910, Manuel S. Gaitan played semi-professional ball in the early 1930s for the Commercial Club in South Colton. He played several positions, including pitcher, third base, and outfield, and was known for hitting home runs. Gaitan was drafted by the New York Giants baseball club but decided not to join the team because he was getting married. He passed away in 2001 at the age of 91. (Courtesy of Andrew Gaitan.)

Robert "Bobby" Perez demonstrates his windup in his Corona Athletics uniform in the early 1950s. Perez and Luis Uribe graduated from Corona High School in 1950 and were both scouted by major-league teams. Soon after graduation, Bobby signed with the Brooklyn Dodgers organization and played two years of minor-league baseball. In 1950, he was with the Bisbee-Douglas Cooper Kings of the Class C Arizona-Texas League. The following year, he played with the Reno Silver Sox of the Class D Far West League.

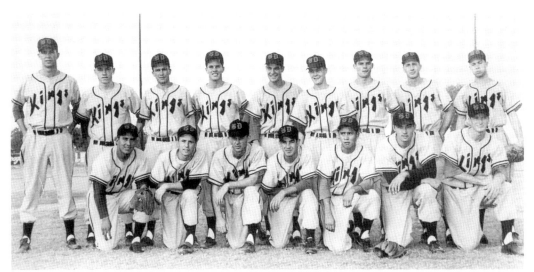

Luis Uribe was signed by the Pittsburgh Pirates after graduating from Corona High School in 1950. Uribe (first row, fourth from right) was a catcher for two years for the Bisbee-Douglas Copper Kings Class C team in the Arizona-Texas League. Robert "Bobby" Perez (first row, third from right), another Mexican American player on the team, was a teammate of Uribe's at Corona High School. (Courtesy of Carlos Uribe.)

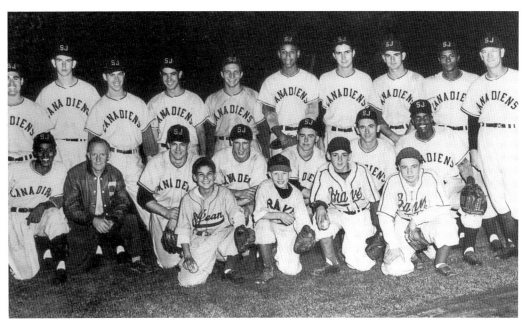

In 1952, Luis Uribe (third row, fourth from left) was assigned to the Pirates' St. Jean Canadiens team in the Class C Provincial League. Later in the same year, he played for the Modesto Reds of the California League. Luis's older brother Carlos played in the minor leagues with the Cleveland Indians organization. (Courtesy of Carlos Uribe.)

March 21, 1947

Mr. Natitivad Cortez,
737 Quarry St.,
Corona, California

Dear Mr. Cortez:

Spring training gets under way Sunday, March 30th., at Bakersfield, California, for our Tucson Base Ball Club. All players to report to the Bakersfield Ball Club office, Padre Hotel, for registration and hotel assignment. Mr. Charles Carson and Tony Governor will be in charge.

Monday, March 31st the practice will officially get under way.

<u>Transportation:</u>
You pay your own transportation cost from your town to Bakersfield, California. Immediately on your arrival we will reimburse you for said railroad or bus fare, plus your meal money. Turn in your expense sheet on your arrival to the base ball office in Bakersfield.
<u>Equipment:</u>
Be sure to bring your sweat shirts, sweat sox, glove, shoes and windbreaker.

Kindly send a letter or wire immediately on confirmation of this letter; what time to expect you.

Looking forward to your arrival and wishing you a fine base ball year this season.

 Wish Best Wishes,

 Eddie Stumpf,
 West Coast Director Cleveland Farm System
 P.O. Box 1727, Bakersfield, Cal.
 Padre Hotel

P.S. Registration day is Sunday, March 30, all day. Not Saturday, March 29, or Monday, March 31, but definately March 30. Adjust yourself accordingly. Kindly fill out quiestionnaire enclosed, and return to our office.

This is the letter that the Cleveland Indians sent to Tito Cortez authorizing him to report to spring training in 1947. He played for the Tucson Cowboys, Cleveland's affiliate in the Class C Arizona-Texas League, for one season and then returned home. As a result of throwing so many innings, he suffered hamstring injuries. Cortez's career ended with an eye injury sustained while playing with the Corona Athletics. (Courtesy of Richard Cortez.)

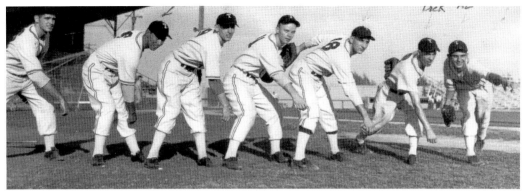

Tito Cortez was born in 1918 in Corona. By the late 1930s, he was an outstanding pitcher for the Corona Athletics, one of the greatest teams in the Inland Empire. On that team were unrelated friends Alfredo and Henry Uribe. He signed with the Cleveland Indians in 1946 and is seen here, second from left, with their farm team in Tucson. His friend Ray Bega was also scouted as a prospect. Tito later drove a citrus truck and retired from the Corona School District before his passing in 2008. (Courtesy of Richard Cortez.)

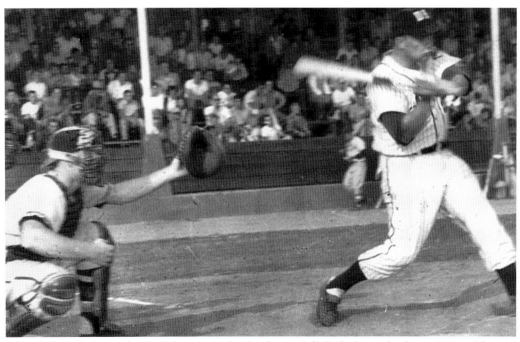

John Galvin Park was formerly known as Jay Littleton Ball Park. It was built in 1937 and hosted professional baseball for only one season when the Ontario Orioles of the Sunset League played there in 1947. Maury Encinas played for the Orioles in 1947, while his brother Tommie pitched against Jackie Robinson during an exhibition game at John Galvin Park. Al Vasquez remembers watching Billy Martin play there as well.

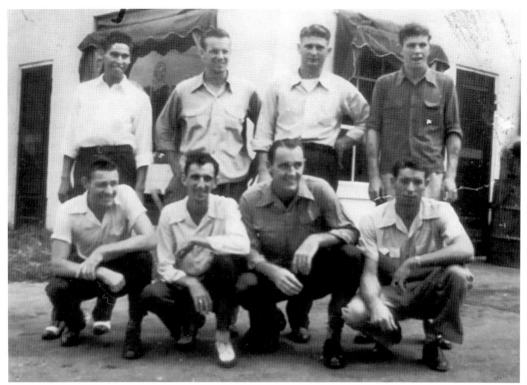

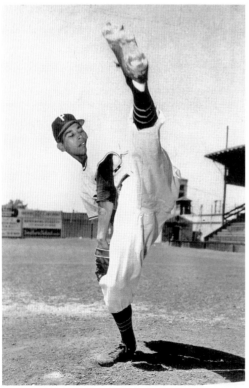

Tommie Encinas (second row, far left), a right-handed pitcher, was signed by Bob Tafoya to a contract with the Boston Braves organization in 1946 and began his professional career in Leavenworth, Kansas, in the Class C Western Association. In 1947, Tommie was traded to the Pittsburgh Pirates organization, where he played for the Uniontown Coal Barons in Pennsylvania and the Selma Cloverleafs in Alabama. (Courtesy of the Tommie Encinas family.)

In 1948, Tommie was assigned to the Waco Pirates in Texas. During this time, he returned home to Pomona to marry Barbara Ruiz. In 1950, he played with the Double-A New Orleans Pelicans of the Southern Association. In 1951 and 1952, Tommie played with the Mexicali Eagles, a Pittsburgh Pirates affiliate in the Class C Southwest International League, and the Hollywood Stars. Following an injury to his elbow, he decided to retire after pitching seven years of professional ball. (Courtesy of the Tommie Encinas family.)

Maurice "Maury" Encinas was born in 1922 in Otterbein, California, and grew up playing baseball in Pomona with his brothers Tommie and George. After graduating from Pomona High School, he pitched for Pomona Junior College in 1941–1942, where he tied the Orange Empire Conference record with 19 strikeouts in a game. Following his college career, he signed with the Ontario Merchants in 1942. (Courtesy of the Maury Encinas family.)

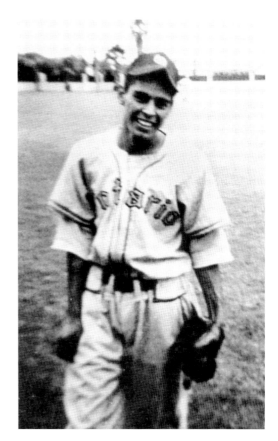

In 1947, Maury Encinas, seen here with his wife, Stella, joined the Ontario Orioles of the Sunset League, where he pitched and played first base and outfield. The following season, he was in the same league with the Mexicali Aguilas. Maury later played for the Pomona Merchants and Beacon Sporting Goods teams. He continues to play with a senior slow-pitch softball team in Chino at the age of 89. Stella was an outstanding softball player in her own right. (Courtesy of the Maury Encinas family.)

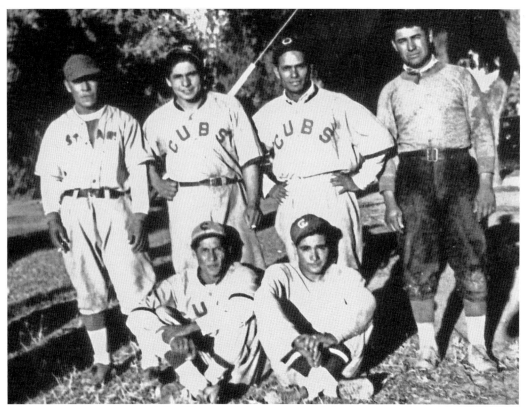

The Chicago Cubs were one of the first major-league teams to hold spring training on the West Coast. The Cubs would come to California, stopping in San Bernardino to play at Perris Hill Park (later renamed Fiscalini Field) for about two weeks before heading out to Catalina Island. In both locations, many of the local Mexican American boys would shag fly balls and serve as batboys. In return, the Cubs would teach them how to bat, field, and pitch and leave their jerseys as souvenirs. Sitting at left is Pete Garcia, and sitting next to him is Tony Colunga. (Courtesy of Angie Torrez Pippins.)

After the Cubs finished spring training, they would leave their uniforms behind for the high school or local youth teams. Lolo Saldana, shown here, is wearing the uniform of Hack Wilson on Catalina Island. Many Mexican Americans still fondly remember their sisters and mothers making alterations to the uniforms so they could use them for games. Foxie Saucedo got Stan Hack's uniform. In fact, for years, the Avalon High School team photograph in the school annual showed the players wearing Cubs uniforms. (Courtesy of Marcelino Saucedo.)

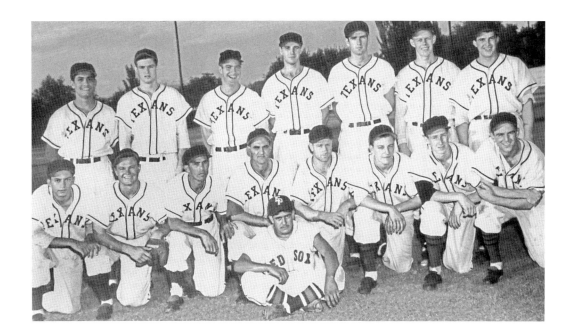

Above, Charlie Sierra (first row, far left) played with the Boston Red Sox farm team in El Paso, Texas, in 1947 and 1948 in the Class C Arizona-Texas League. Below, Sierra (third from right) recalled that during the 1947 season, the El Paso team traveled in three station wagons. The photograph was taken just as the team departed for Bisbee, Arizona. On the return ride home to El Paso after the game, one of the players asked the manager to let him drive. While driving, the player fell asleep, and the station wagon flipped over in the desert. Sierra was asleep in the back seat between two other players. Charlie was unhurt, but the two players next to him were injured. Charlie was with the El Paso club for two years, and there were three Mexican players on the team. Many fans from Juarez would cross the border to see the El Paso team play. (Courtesy of Charlie Sierra.)

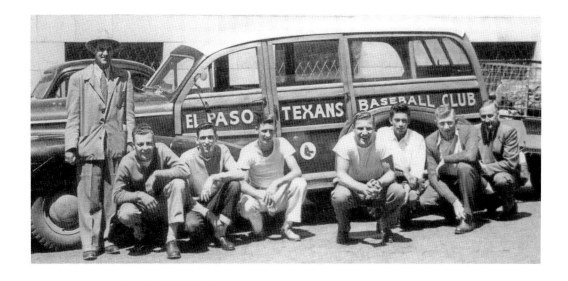

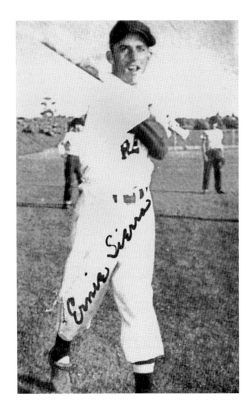

Charlie Sierra's brother Ernie was also an outstanding athlete. An infielder for the San Jose Red Sox team in the California League from 1947 to 1951, Ernie was the team's Most Valuable Player for three years and was selected to the all-star team for three years. He excelled at several positions, including second base, shortstop, and third base. Ernie's professional career, which spanned 11 seasons, began in 1942 in Twin Falls, Idaho, in the Pioneer League. When World War II broke out, he served in the US Air Corps, making dozens of bombing missions over Europe and Asia. (Courtesy of Charlie Sierra.)

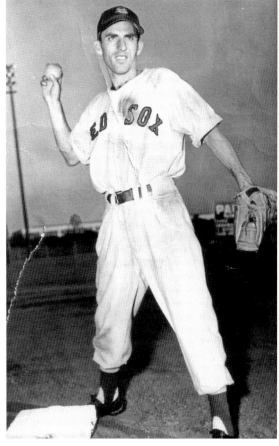

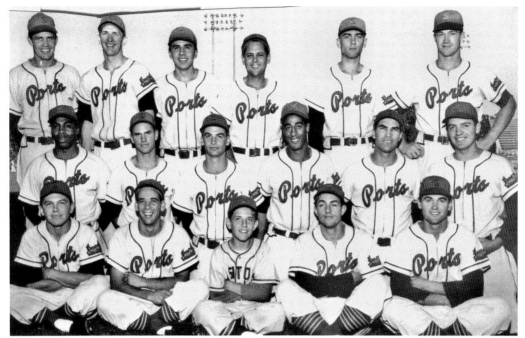

Armando Perez (third row, third from left) was an outstanding player at Roosevelt High School and East Los Angeles College. In 1956, he signed a contract with the Baltimore Orioles organization and played outfield for the Vancouver Mounties of the Pacific Coast League and Stockton Ports of the California League. In 137 games for Stockton, he hit .299 with eight home runs and 100 runs batted in. (Courtesy of Armando Perez.)

After suffering a shoulder separation while playing for Seattle, Armando (second row, fourth from left) decided to retire from the professional game and attend college. He earned his Master's degree in counseling and devoted his life to education. Armando continued to play Sunday baseball and coach youth teams. In 1970, he founded the Montebello Stars organization, which produced many outstanding scholar-athletes and assisted them with scholarships and mentoring. (Courtesy of Armando Perez.)

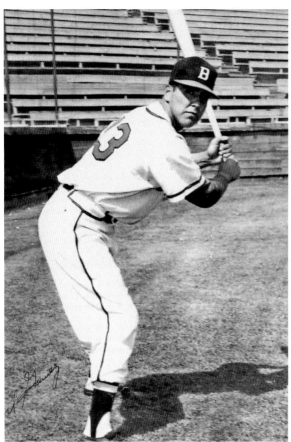

Gil Gamez Jr. was a catcher and first baseman when he played professionally during the 1950s for the Boise Braves, Paris Orioles, Phoenix Stars, Portland Beavers, Salem Senators, Salt Lake City Bees, and Stockton Ports. He also starred for the Carmelita Chorizeros and umpired for 22 years at the prep, collegiate, and semi-professional levels. After retiring from umpiring, he became a major-league scout for the Seattle Mariners, California Angels, Kansas City Royals, Milwaukee Brewers, and Montreal Expos. (Courtesy of Gil Jr. and Alma Gamez.)

Some major-league organizations sponsored junior teams on the West Coast, which were generally managed by scouts who would recruit the best players and assess their talents for possible contracts with the big clubs. A few Mexican Americans were asked to play for these junior teams, including Bob Lagunas (first row, second from right), who was on the Junior Yankees. The players were given the uniforms worn by the major leaguers the previous season, and Lagunas wore the uniform of Yogi Berra. (Courtesy of Bob Lagunas.)

Marcelino Saucedo (far left) served as a translator for the Pittsburgh Pirates minor-league team in Bradenton, Florida, in the summer of 1968. Eight players could not speak nor understand English, so Marcelino helped them by translating baseball fundamentals in Spanish. The coaches were stationed in various locations in the field, with Marcelino visiting each area to translate what the coaches were teaching. Also in the photograph is manager Bud Prichard (second from left) and coach Harvey Haddix (kneeling). (Courtesy of Marcelino Saucedo.)

Sammy Sandoval (second row, second from right) played for the Stockton Ports in 1952. He was an outstanding player from the community of Riverbank near Modesto. As a youth, he played baseball on the grammar and high school teams in Oakdale and later played community ball with both Los Caballeros and Los Charros. After a season with the Ports, he was drafted into the Army and sent to Korea during the war. He played baseball in the military both in Korea and Japan. After his discharge, he continued playing ball, including in the senior leagues. (Courtesy of Olivia Sandoval.)

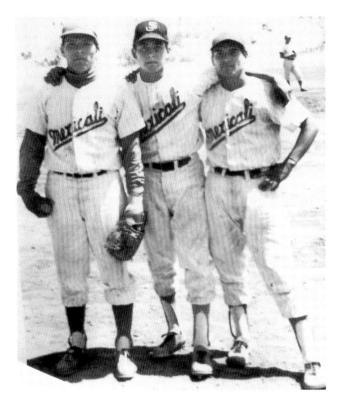

Gabriel de la Torre (center) played professionally with the Pericos de Puebla of the Liga Mexicana from 1969 to 1971 before a shoulder injury forced his retirement. He is between two outstanding Mexican players, Eduardo "Guyo" Rivera (right) and Manuel "Mocho" Olivas (left), who was his catcher. Ten years later, Gabriel had a brief stint with the Mexicali Aguilas, who were affiliated with the San Francisco Giants. De la Torre's portrait hangs in the Mexicali Baseball Hall of Fame for his outstanding career, highlighted by his 40-strikeout game. (Courtesy of Gabriel de la Torre.)

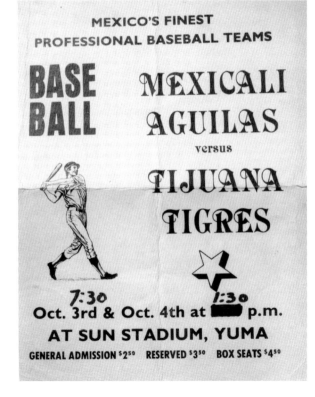

THE LATINO BASEBALL HISTORY PROJECT

EL CAMPO DE SUEÑOS

The idea that eventually led to the establishment of the Latino Baseball History Project came from Terry Cannon, the executive director of the Baseball Reliquary and former library technology student at Pasadena City College in the fall of 2004. Since then, the project has been actively involved with collecting, preserving, and promoting the rich history of Mexican American baseball both in California and throughout the United States. The John M. Pfau Library at California State University, San Bernardino has been designated the official site of the project. For the first time, a major university is partnering with academics, students, staff, community groups, and former ballplayers and their families to establish a repository for broadening the understanding and scope of the different roles that baseball has played in promoting the civil, political, cultural, and gender rights of Mexican Americans.

The Latino Baseball History Project's undertakings have included a wide variety of activities, including sponsoring reunions of veteran players, publishing books and journal articles, curating library exhibits, and coordinating special events, such as first-pitch ceremonies to pay tribute to legendary players. Moreover, the project has also organized panel discussions, plaque dedications, book signings, oral interviews, documentaries, and scanning events to collect vintage photographs. The project recently celebrated its third-annual reunion in 2011, where former ballplayers along with family and friends came together to share their stories and breathtaking photographs. The 2011 reunion included a panel with six prominent players representing diverse geographical regions of Greater Southern California. The players spoke eloquently about the impact of baseball on their lives and their respective communities. The reunion's keynote speaker was Alex Montoya, Hispanic outreach coordinator for the San Diego Padres. In addition, two families, the Barrios and the Felipes, donated three gloves and a uniform to the project's archival collection. All author royalties from the sales of this book go directly to support the Latino Baseball History Project.

For the players and their families, the Latino Baseball History Project is truly a field of dreams, where great players can once again relive their baseball glory of yesteryear.

At California State Polytechnic University, Pomona in May 2011, former players from throughout Southern California threw out the ceremonial first pitch prior to a game between the Broncos and the Golden Eagles from California State University, Los Angeles. Each player was introduced as they took turns throwing the ball to home plate. From left to right are Bob Lagunas, Tommie Encinas, Maury Encinas, Richard Peña, Al Padilla, and Ignacio Felix.

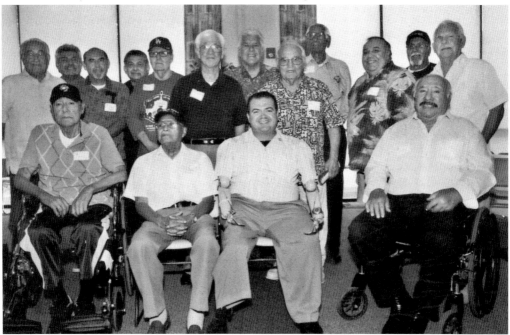

The Latino Baseball History Project sponsors an annual baseball reunion in the summer, where players, family members, friends, and fans come together to enjoy and recall stories of the "Golden Age" of Mexican American baseball. The keynote speaker for the third-annual reunion in 2011 was Alex Montoya, Hispanic outreach coordinator for the San Diego Padres, who is seated in the first row, second from the right.

Sal Valdivia Jr. wears his 1964 letterman's sweater and holds his father's 1941 letterman's sweater. Both were outstanding baseball players at Beaumont High School. In 2008, after a nearly 50-year effort to get the city to rename the park on the south side of Beaumont after his father, the city changed the name to Sal Valdivia Park. Of the five parks in Beaumont, it is the only one named after a Mexican American.

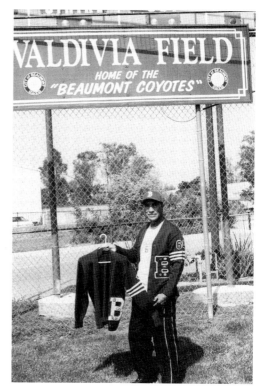

Ernie Benzor holds one of several trophies that his father, Ernest, received during his baseball-playing days in Casa Blanca in Riverside County. Ernie proudly wears his father's high school letterman's sweater at a park where his father played baseball in his youth. The diamond has been renamed in tribute to S.Sgt. Ysmael Villegas, a local hero who won the Congressional Medal of Honor during World War II.

Amado Mayo Briones, who passed away in 1997 at age 86, was an outstanding sports star at Chino High School. Because he dedicated his entire life to youth sports in the city of Chino, he was presented with a commendation from California state senator Ruben S. Ayala. His four children are, from left to right, Chuck, Stella, Annie, and Amado Jr. ("Chico"). They are holding their father's high school letterman's sweater at the park that was named after their father in 1978. (Courtesy of the Briones family.)

Oscar Gonzales wears his Calexico Monarchs jersey and cap from his 1960 community team. A grassroots campaign is afoot to name the park shown here after Gonzales, an outstanding athlete at Calexico High School. The park is only a few hundred yards from the Mexican border. The Coachella Valley has produced outstanding baseball teams and players from the communities of Calexico, Blythe, El Centro, Brawley, and Coachella. Many local Mexican Americans also played across the border for the city of Mexicali.

The gathering of photographs for the Latino Baseball History Project is accomplished primarily through public scanning events. In 2011, in Modesto, California, near the city of Riverbank, players shared their precious photographs and wonderful stories. From left to right are Gustavo Rodriguez, Felix Ulloa Jr., Phyillis Perez, Patricio Rodriguez, and Lupe Perez. All four men, and the late husband of Phyllis, Jess Perez, played for the Riverbank Merchants.

Former players, family members, and friends bring baseball photographs and other related items to be scanned and documented by the Latino Baseball History Project staff in 2011 in the city of Westminster in Orange County. In the foreground is Dr. Richard Santillan signing copies of the book Mexican American Baseball in Los Angeles, which he authored with Dr. Francisco Balderrama. Proceeds from the book sales go to support the project.

Pete Barrios Jr. holds one of three gloves belonging to his late father, Pete, that he donated to the Latino Baseball History Project at the third-annual reunion held in 2011 in San Bernardino. The gloves date back to the late 1920s and early 1930s, when his father played baseball in the Greater Los Angeles area. Pete Jr. still plays senior softball in several leagues around the Los Angeles and Chino areas.

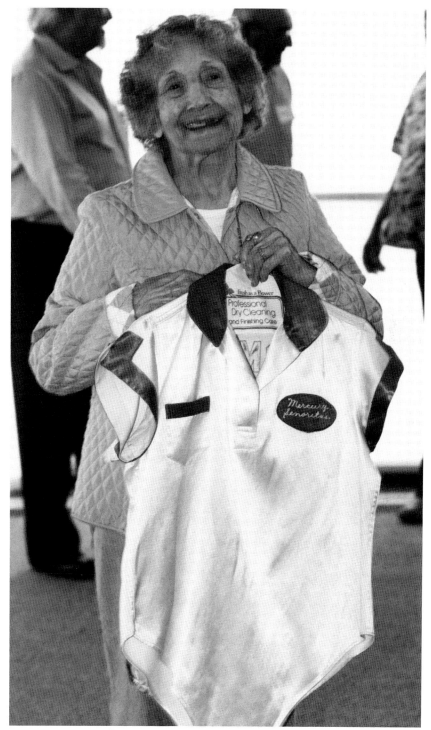

Carmen Lujan, age 86, proudly displays her 1936–1939 Colton Mercury Señoritas uniform. Lujan was one of several ballplayers who attended the 2010 Latino Baseball History Reunion at California State University, San Bernardino.

BIBLIOGRAPHY

Alamillo, José. *Making Lemonade Out of Lemons: Mexican American Labor and Leisure in a California Town, 1880–1960*. Urbana and Chicago: University of Illinois Press, 2006.

Balderrama, Francisco E. and Richard A. Santillan. *Mexican American Baseball in Los Angeles*. Charleston, SC: Arcadia Publishing, 2011.

Dominguez-Nevarez, Carmen. *Inland Empire Paves the Way for Cesar E. Chavez*. Fontana, CA: Zoe Life Publications, 2010.

Fraire, John. "Mexicans Playing Baseball in Indiana Harbor: Midwest Mexican American Identity in the Interwar Period." PhD dissertation in progress, Union Institute of the University of Cincinnati.

Frye, Harry and Roger Schmidt. *The Blue and Grey: San Bernardino Valley College Sports, 1926–2011*. San Bernardino, CA: Crown Printers, 2011.

Garcia, Matt. *A World of Its Own: Race, Labor, and Citrus in the Making of Greater Los Angeles, 1900–1970*. London and Chapel Hill, NC: University of North Carolina Press, 2001.

Iber, Jorge and Samuel O. Regalado, eds. *Mexican Americans and Sports: A Reader on Athletics and Barrio Life*. College Station, TX: Texas A&M University Press, 2007.

Magdalena, Amanda. "Peloteras de Casa: Baseball's Role in Creating Gender Capital for Mexican American Women." Master's thesis, Tulane University, 2011.

———. "Este Baseball de Nuestros Suenos: Baseball as a Carnivalesque Space of Mexican Negotiation of Gender and Sexuality, 1930–1960." Unpublished paper.

———. "Negotiating Citizenship: Identity, Masculinity, and Sexuality within American Baseball, 1910–1960." Unpublished paper.

Maulhardt, Jeffrey Wayne. *Baseball in Ventura County*. Charleston, SC: Arcadia Publishing, 2007.

Ocegueda, Mark. "Lopez v. Seccombe: The City of San Bernardino's Mexican American Defense Committee and its Role in Regional and National Desegregation," *California State University, San Bernardino Journal of History*. 3 (2010): 1–32.

Uribe, Sandra. "The Queens of Diamonds: Mexican American Women's Amateur Softball in Southern California, 1930–1950." Unpublished paper.

LATINO BASEBALL HISTORY PROJECT ADVISORY BOARD

Advisory board members for the Latino Baseball History Project at California State University, San Bernardino include:

José M. Alamillo, associate professor, California State University, Channel Islands
Gabriel "Tito" Avila Jr., founding president and CEO, Hispanic Heritage Baseball Museum, San Francisco
Francisco E. Balderrama, professor, California State University, Los Angeles
Tomas Benitez, artist and art consultant
Raul J. Cordoza, dean, Los Angeles Trade-Technical College
Peter Drier, professor, Occidental College
Robert Elias, professor, University of San Francisco
Jorge Iber, associate dean and professor, Texas Tech University
Amanda Magdalena, doctorate student in history, University at Buffalo, the State University of New York
Douglas Monroy, professor, Colorado College
Carlos Munoz Jr., professor emeritus, University of California, Berkeley
Mark A. Ocegueda, doctorate student in history, University of California, Irvine
Samuel O. Regalado, professor, California State University, Stanislaus
Anthony Salazar, Latino Baseball Committee, Society for American Baseball Research
Richard A. Santillan, professor emeritus, California State Polytechnic University, Pomona
Carlos Tortolero, president, Mexican Fine Arts Center Museum, Chicago
Sandra L. Uribe, professor, Westwood College, South Bay Campus, Torrance, California.

Discover Thousands of Local History Books
Featuring Millions of Vintage Images

Arcadia Publishing, the leading local history publisher in the United States, is committed to making history accessible and meaningful through publishing books that celebrate and preserve the heritage of America's people and places.

Find more books like this at
www.arcadiapublishing.com

Search for your hometown history, your old stomping grounds, and even your favorite sports team.

Consistent with our mission to preserve history on a local level, this book was printed in South Carolina on American-made paper and manufactured entirely in the United States. Products carrying the accredited Forest Stewardship Council (FSC) label are printed on 100 percent FSC-certified paper.